# FREE GOODIES

Join Our FB Group and Upload Your Art Work to Get FREE Digital Version Coloring Pages.

http://www.facebook.com/Colograce-100469078353535

For questions and customer service, eamil us at
ColograceColoring@gmail.com

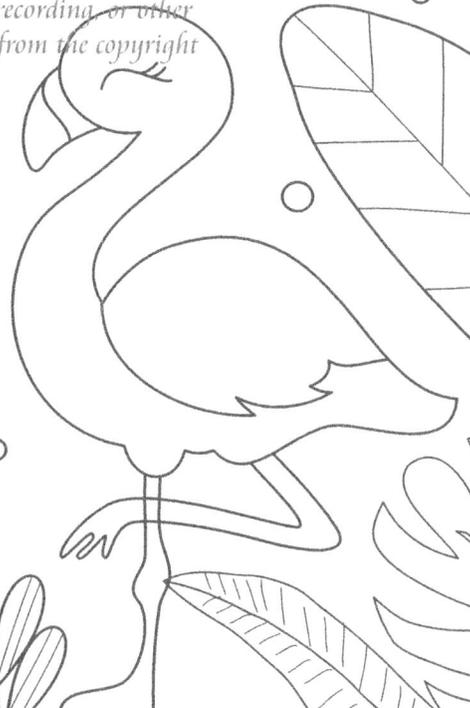

# Steps to a Relaxing Coloring

As an adult, you can enjoy coloring just as much as you did as a child. To make it a truly relaxing experience, try following these steps:

1. Find a quiet space. It's easier to focus on what you are doing when there are no distraction.
2. Organize your materials. Lay out your coloring book and crayons or pens.
3. Set the mood. Turn on some tranquil music, diffuse lavender or another relaxing oil and make sure you have your preferred drink at hand.
4. Select your picture. Which image speaks to you today? That's the one you should color.
5. Choose your palette. Select the colors you will be using for your image.
6. Begin coloring. This is the fun part. Don't worry about getting everything perfect, just start.

Allow yourself to relax and focus on the coloring. You'll find it is an amazing way to alleviate stress and take a little time out from the day's hassles. If you feel don't want to do it anymore, just stop!

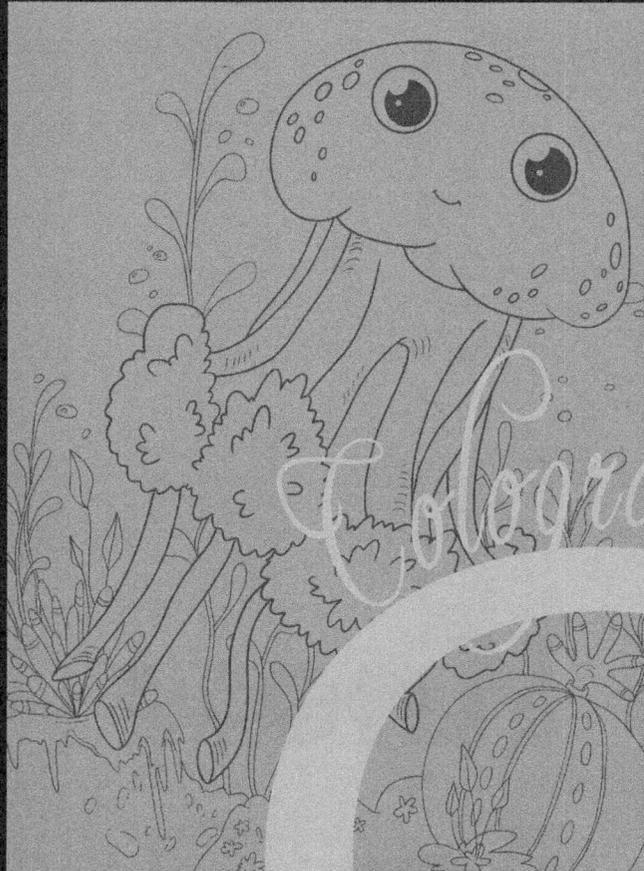

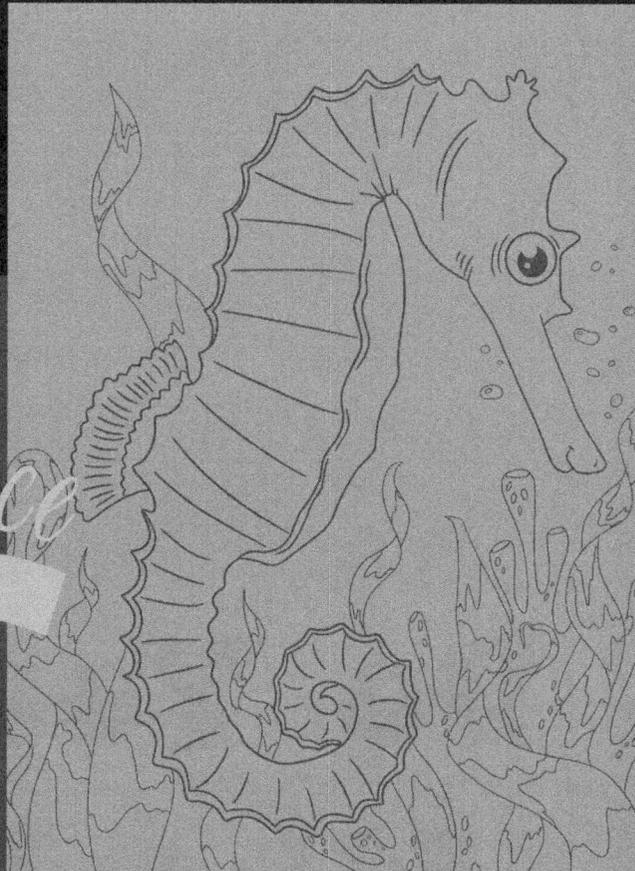

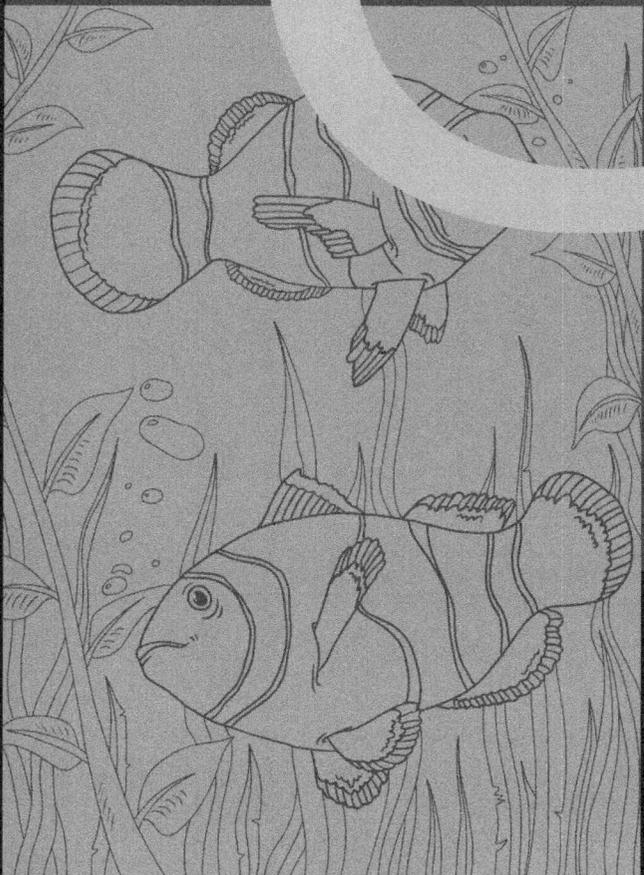

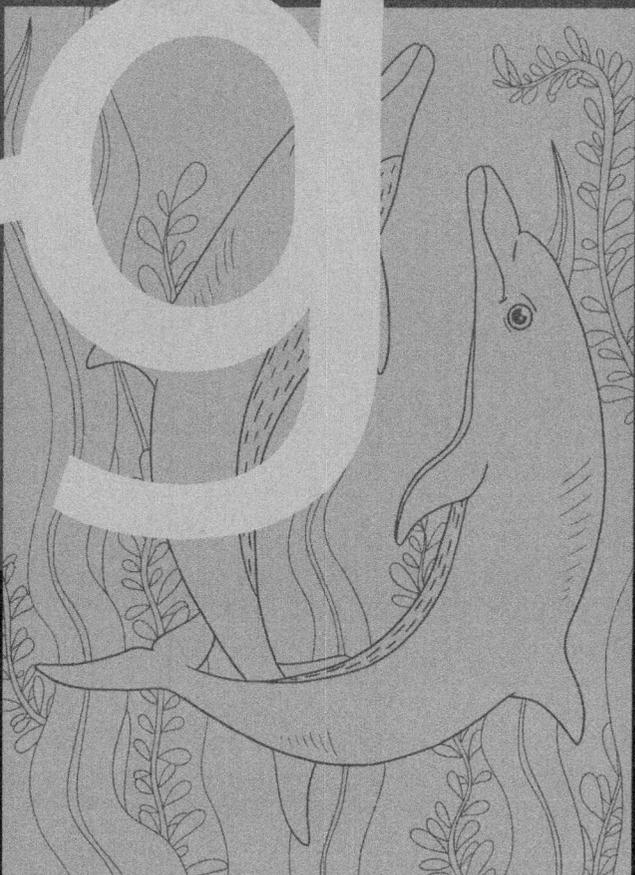

# Do You Know Who I Am ?

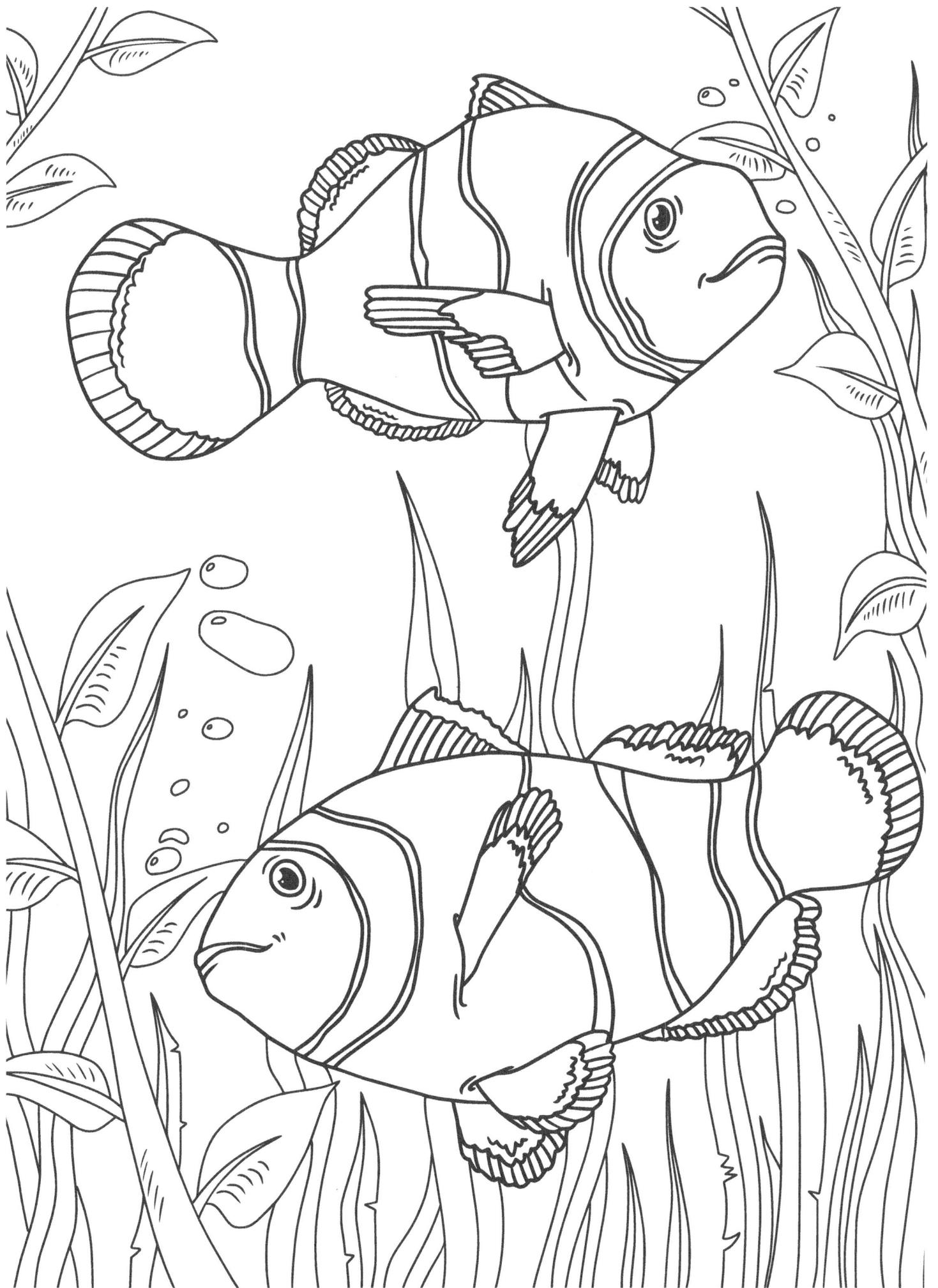

# Do You Know Who I Am ?

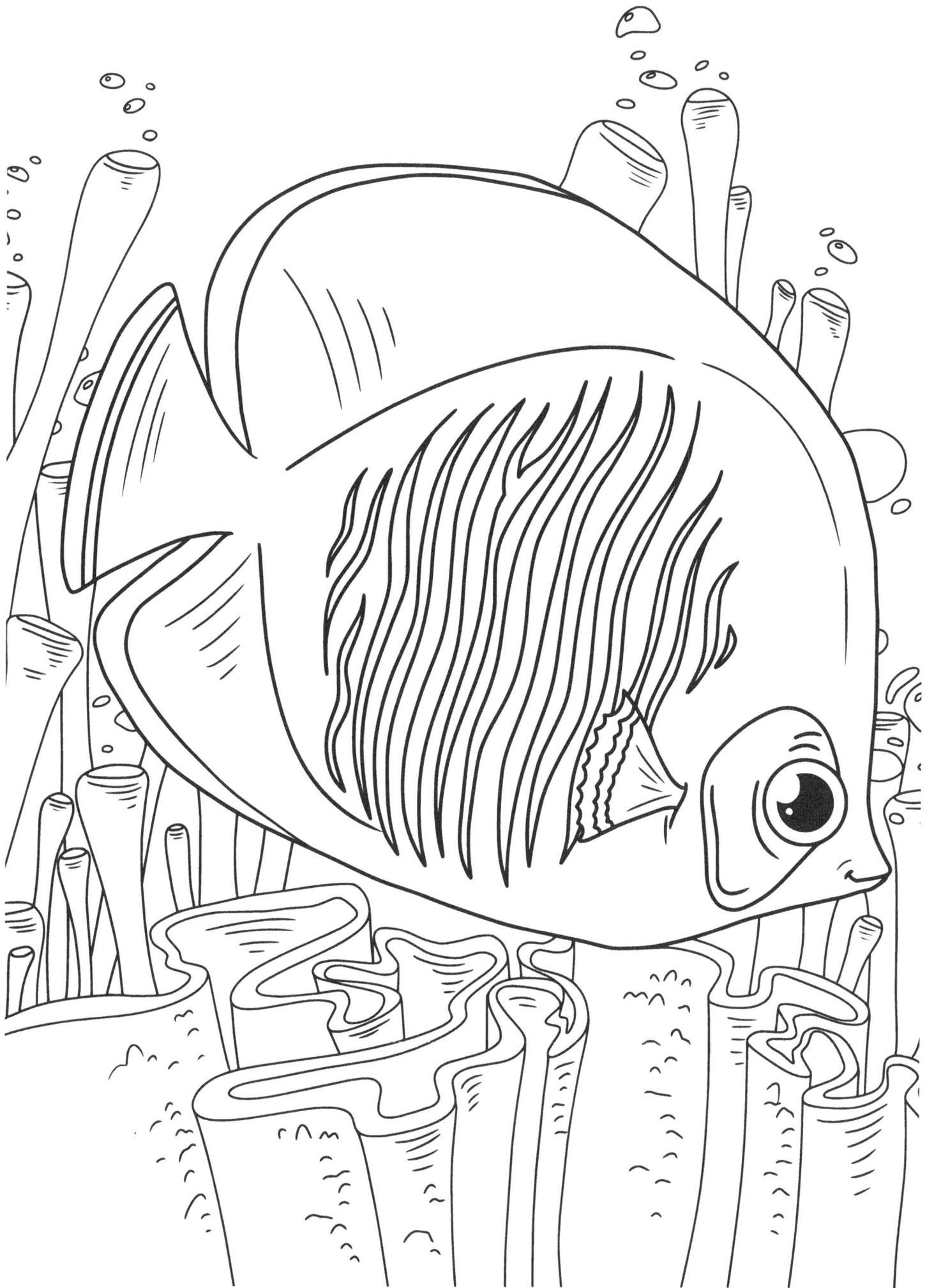

# Do You Know Who I Am ?

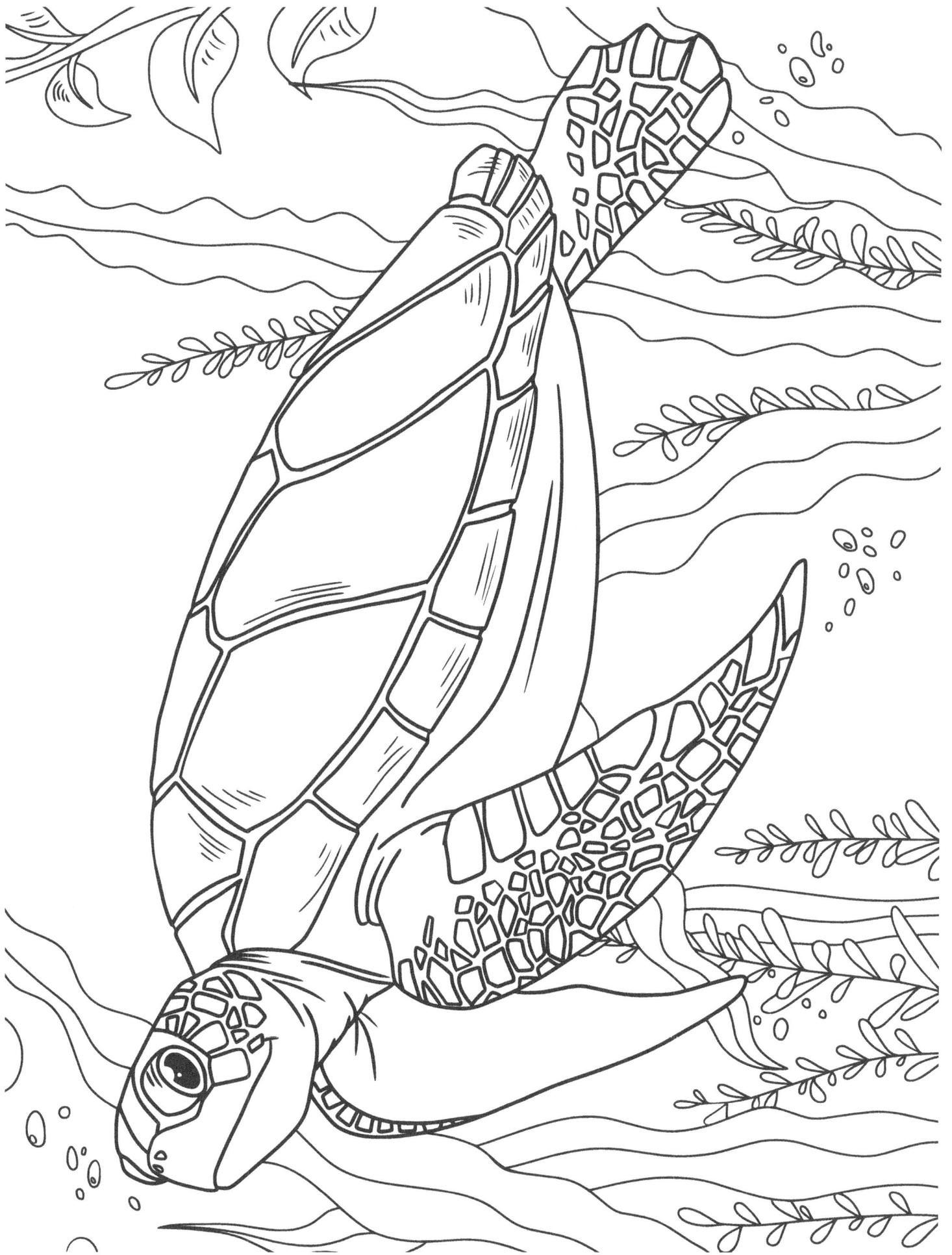

# Do You Know Who I Am ?

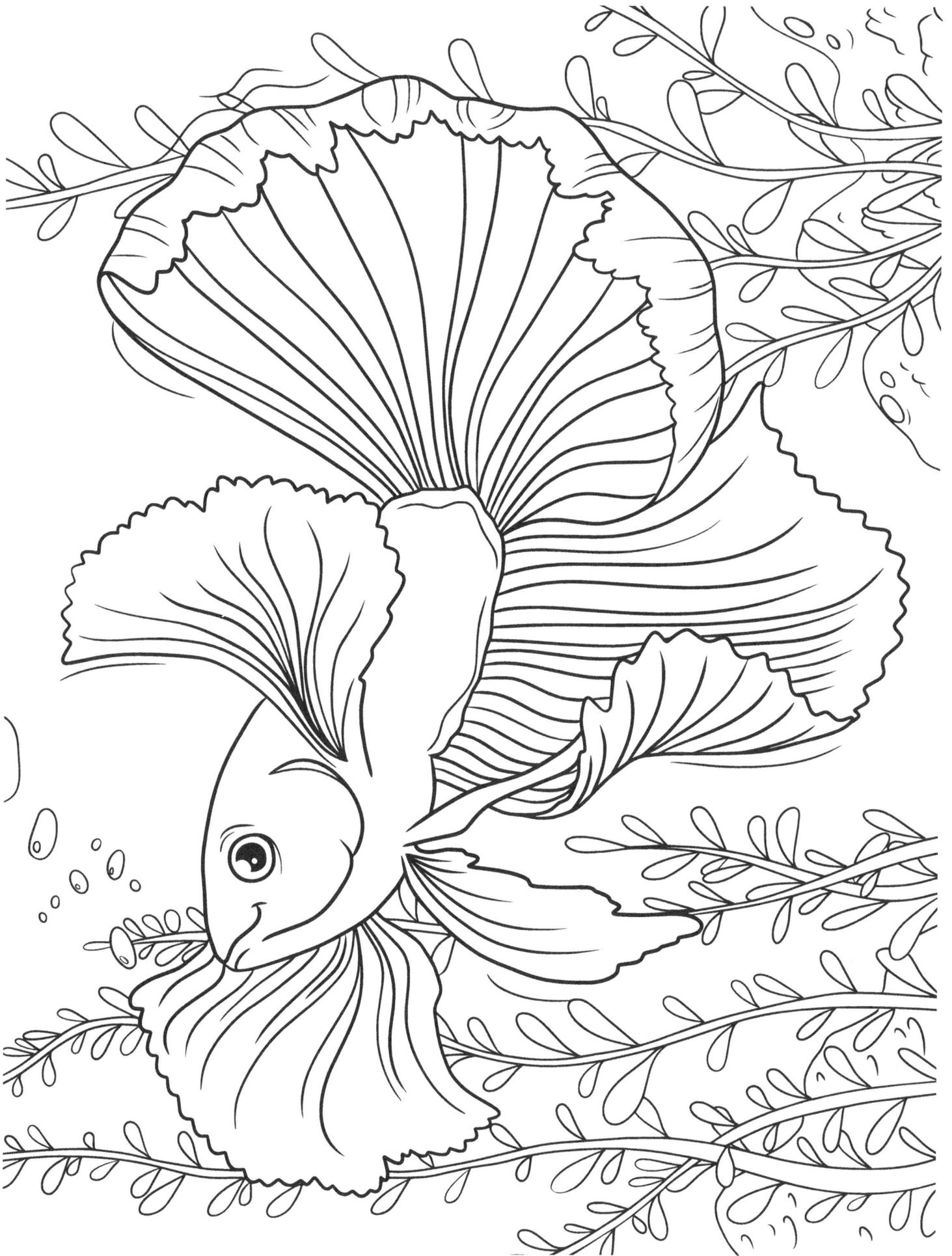

# Do You Know Who I Am ?

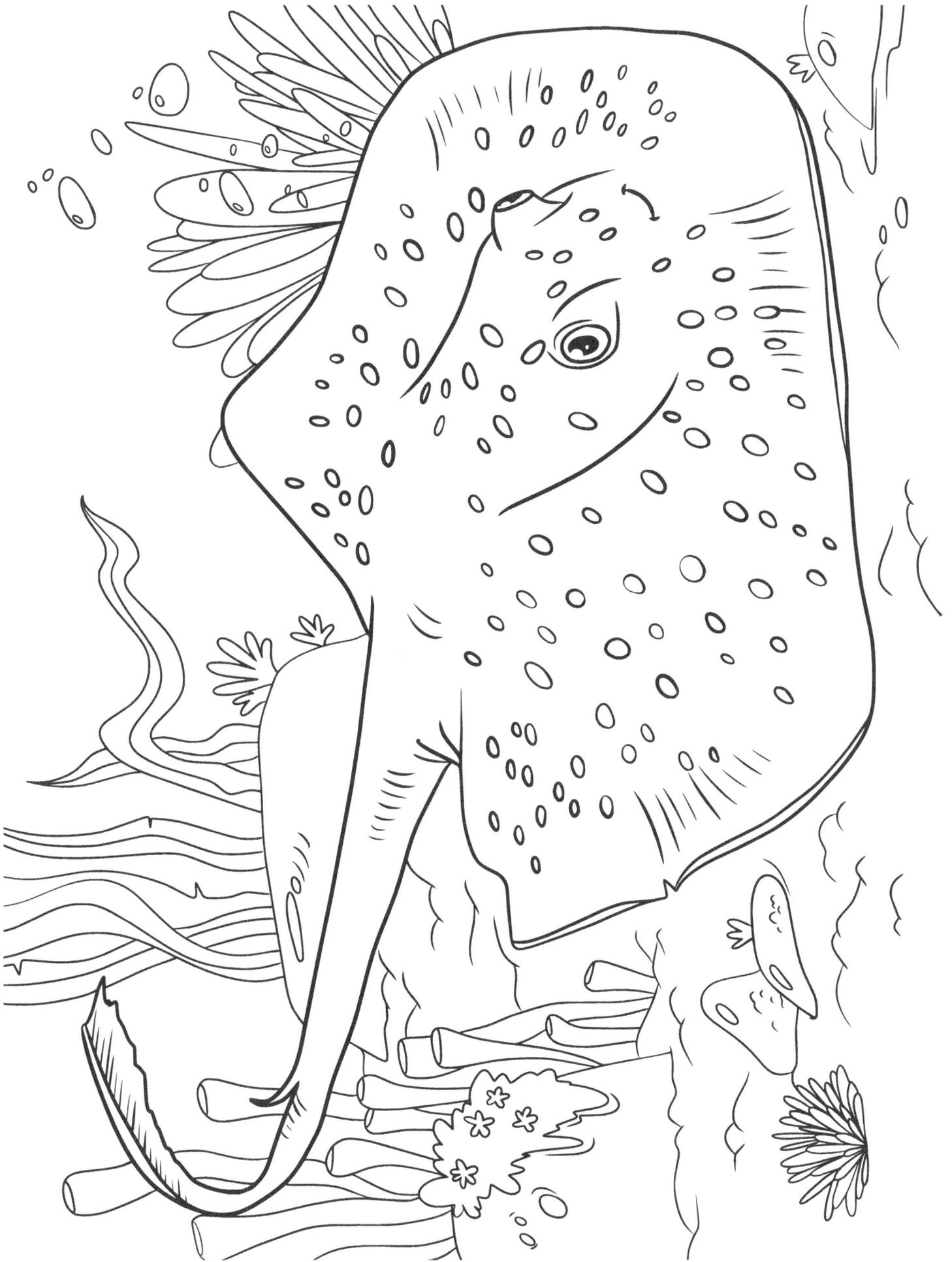

# Do You Know Who I Am ?

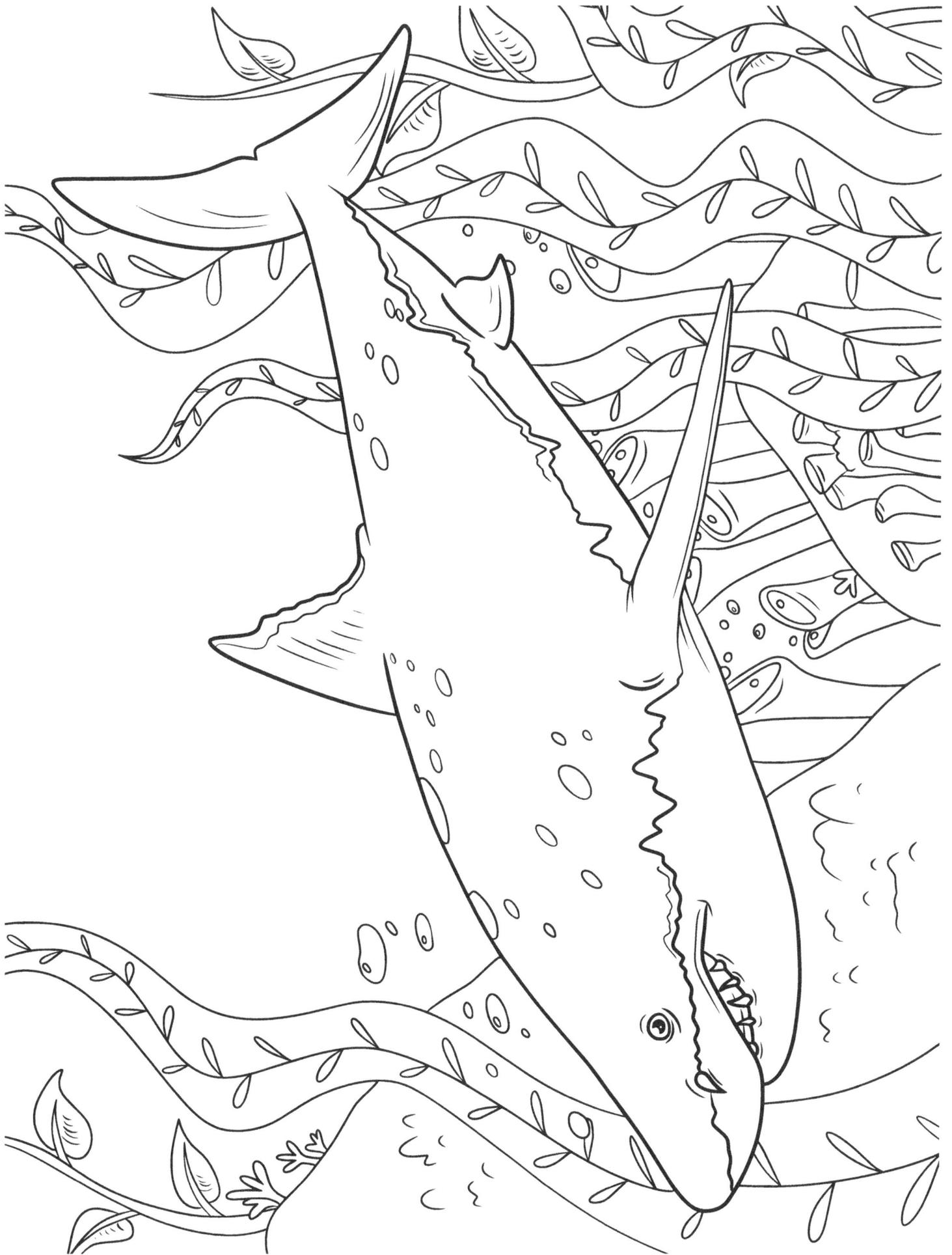

# Do You Know Who I Am ?

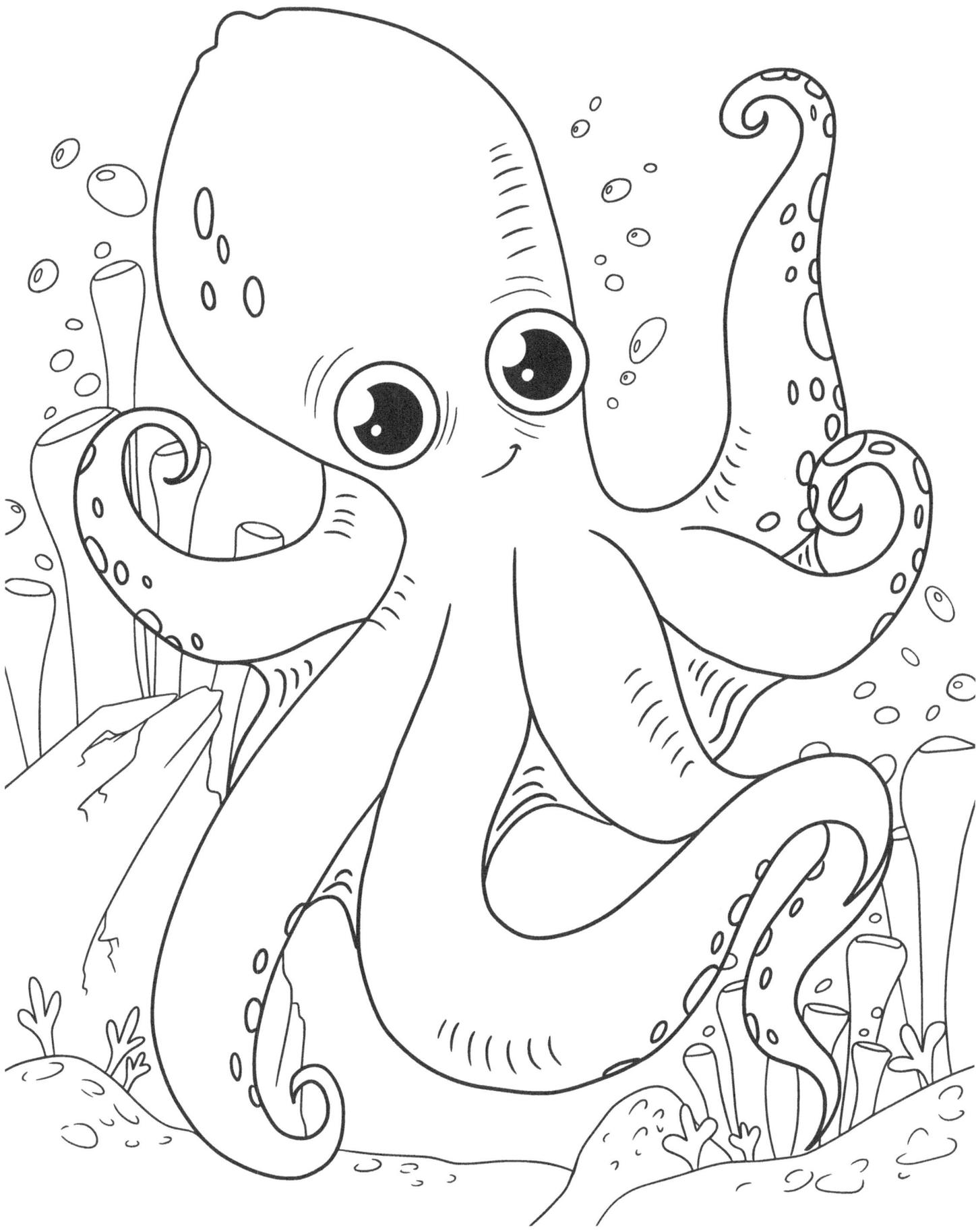

# Do You Know Who I Am ?

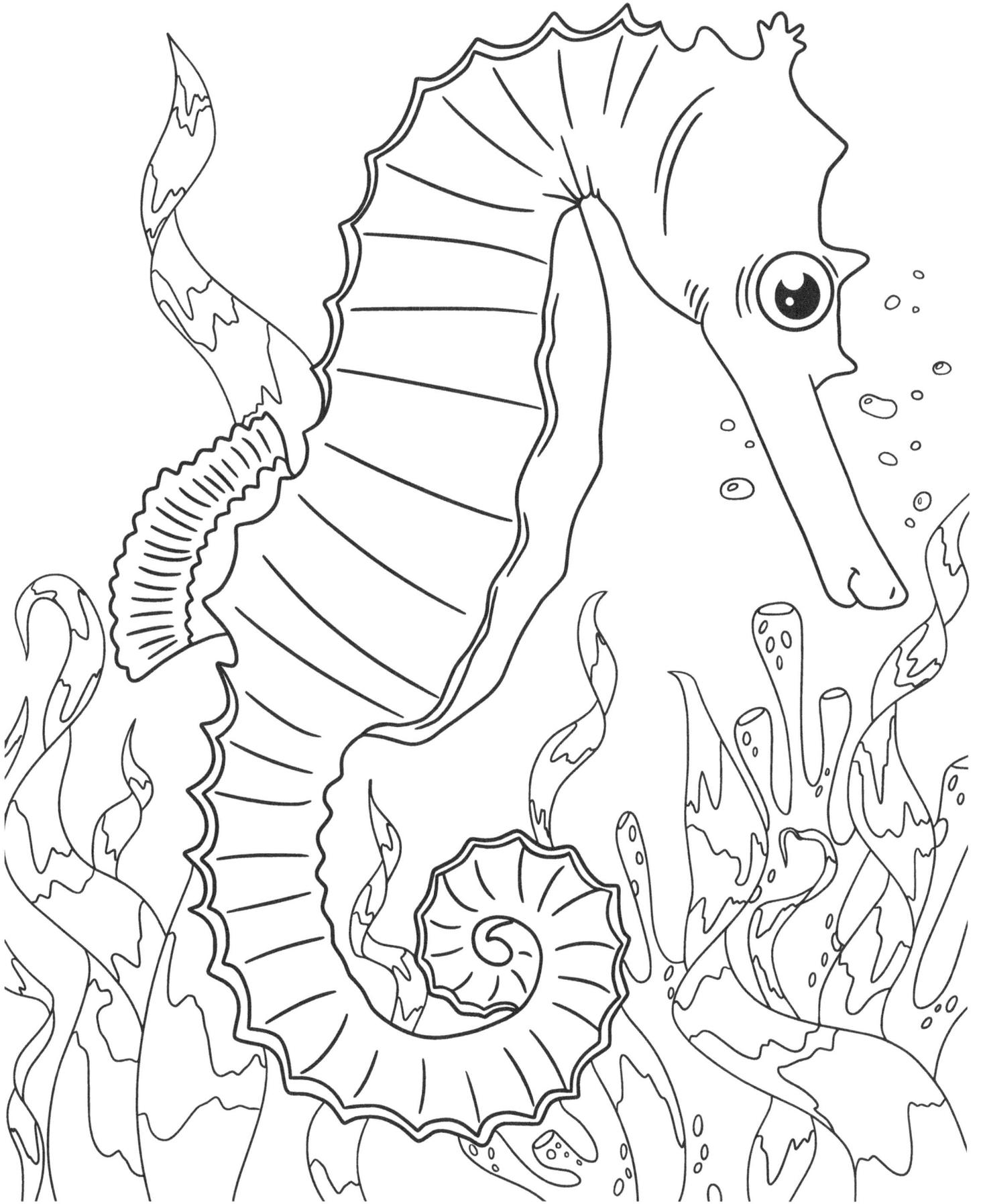

# Do You Know
# Who I Am ?

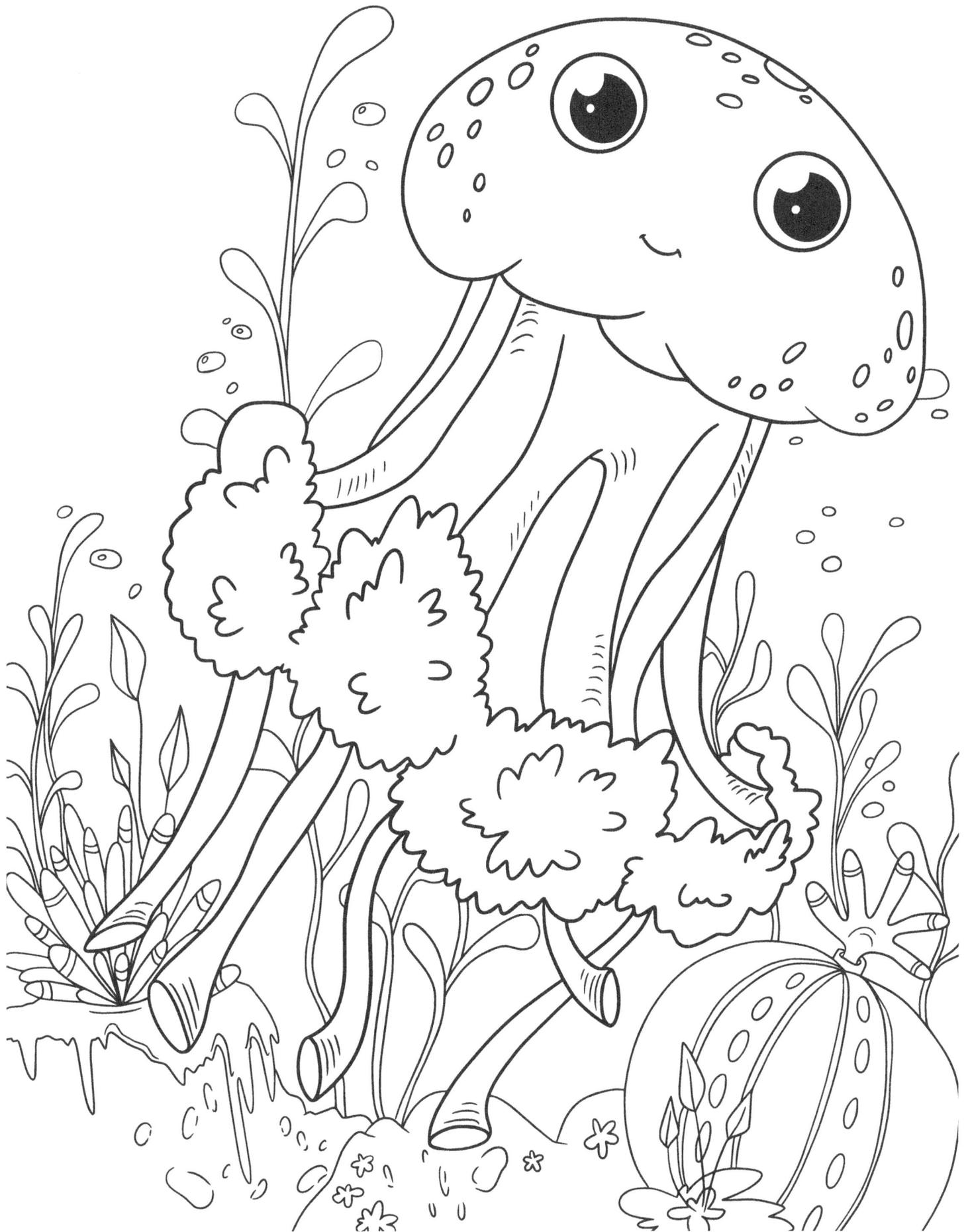

# Do You Know Who I Am ?

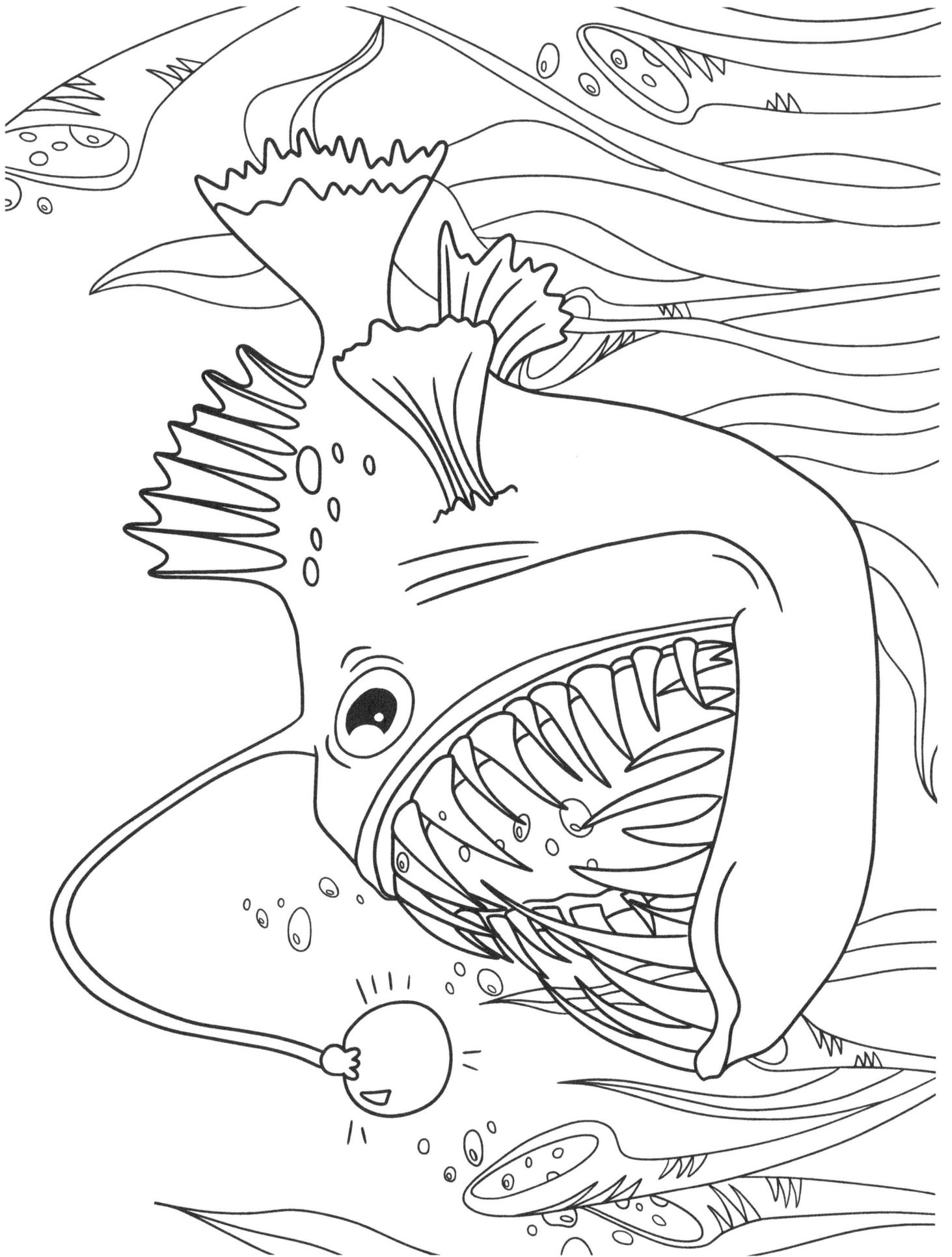

# Do You Know Who I Am ?

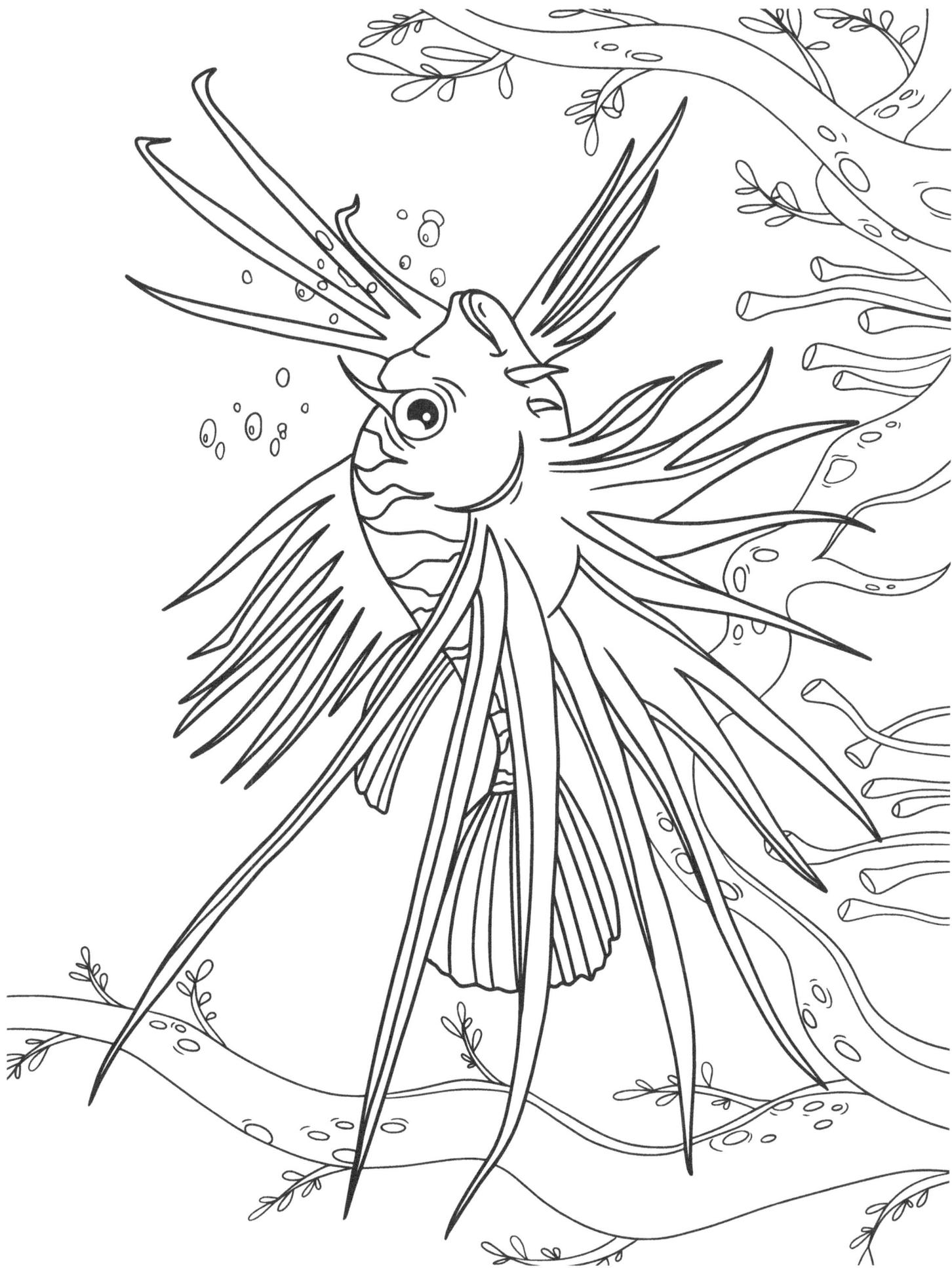

# Do You Know Who I Am ?

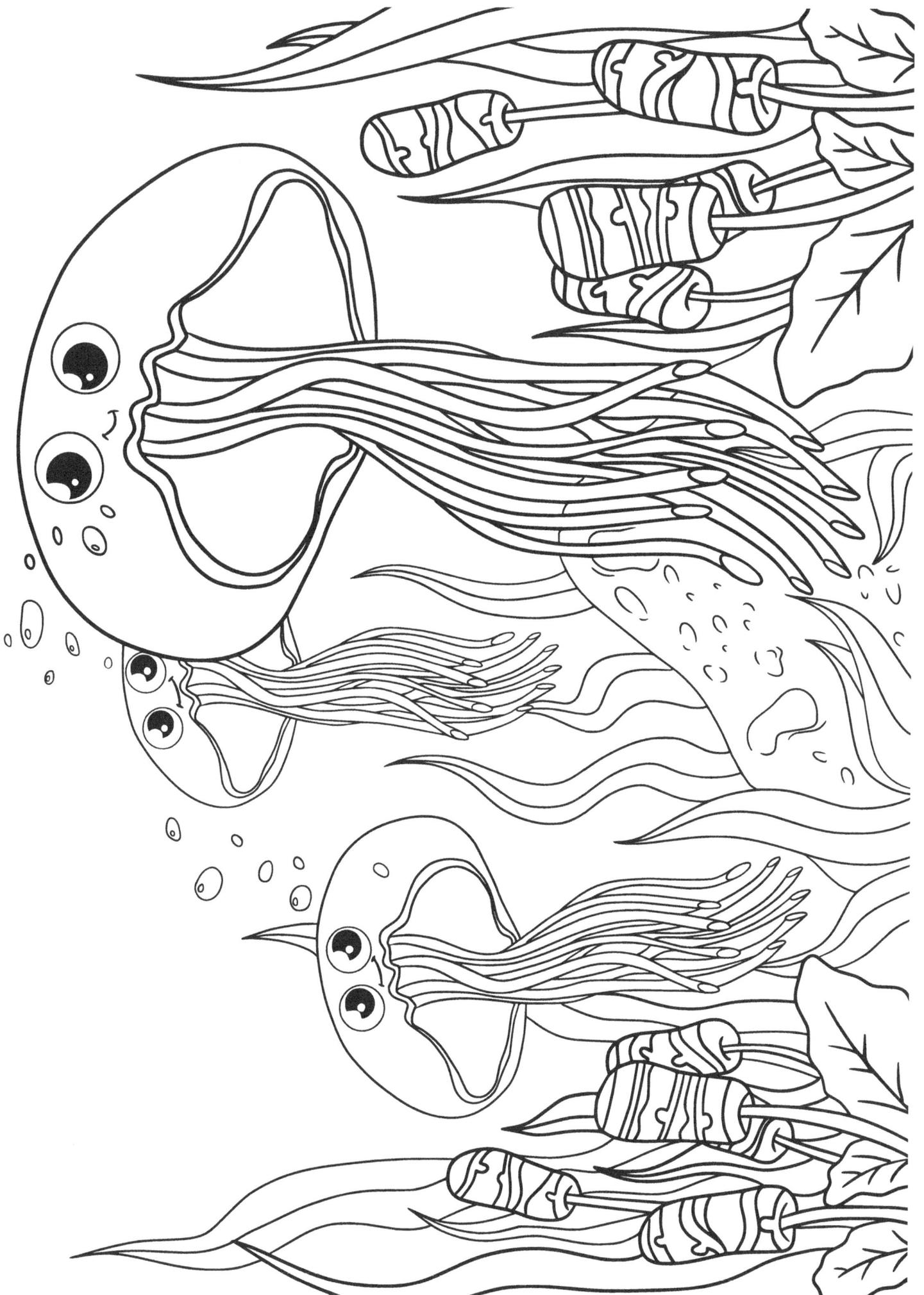

# Do You Know Who I Am ?

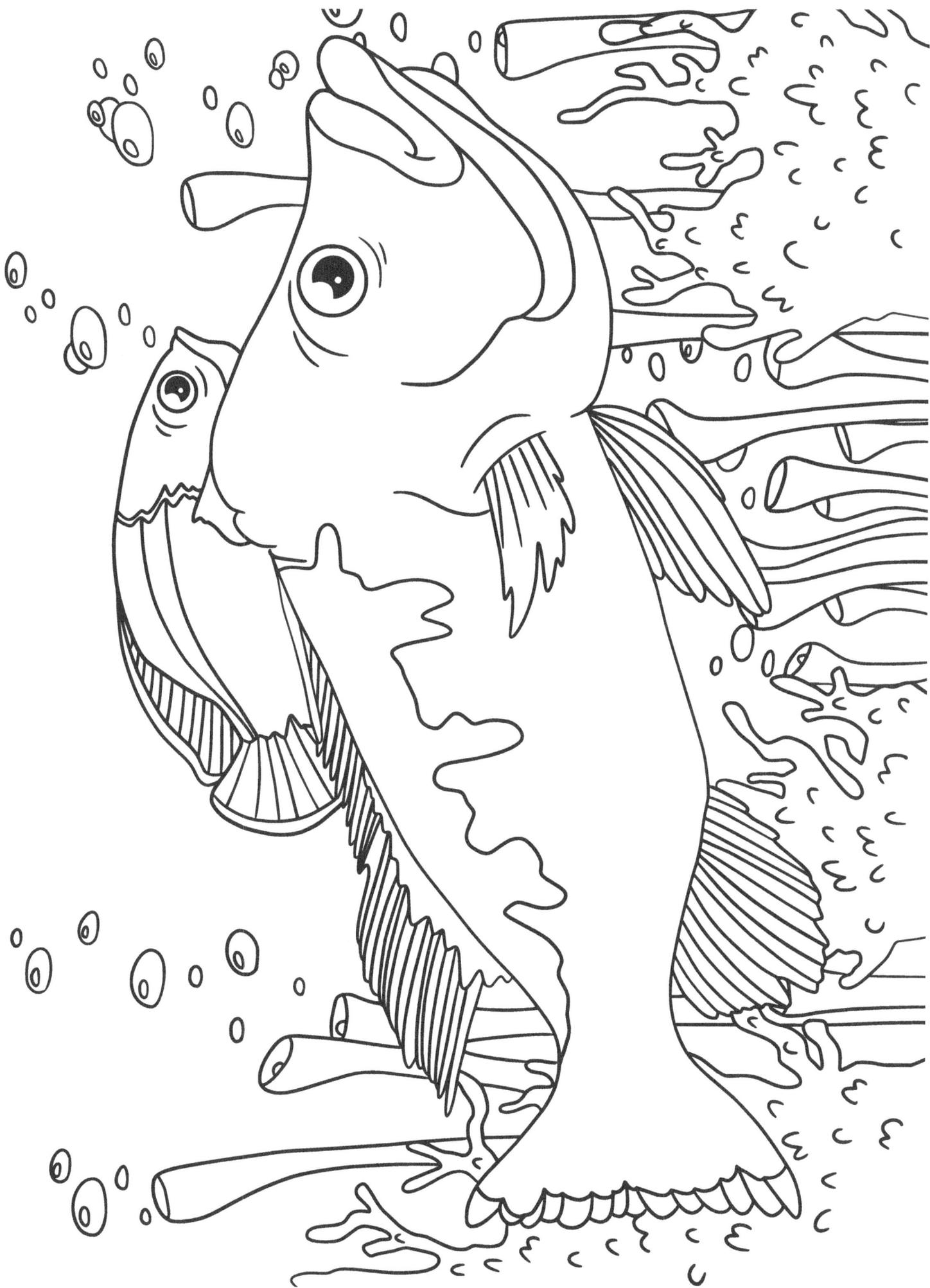

# Do You Know Who I Am ?

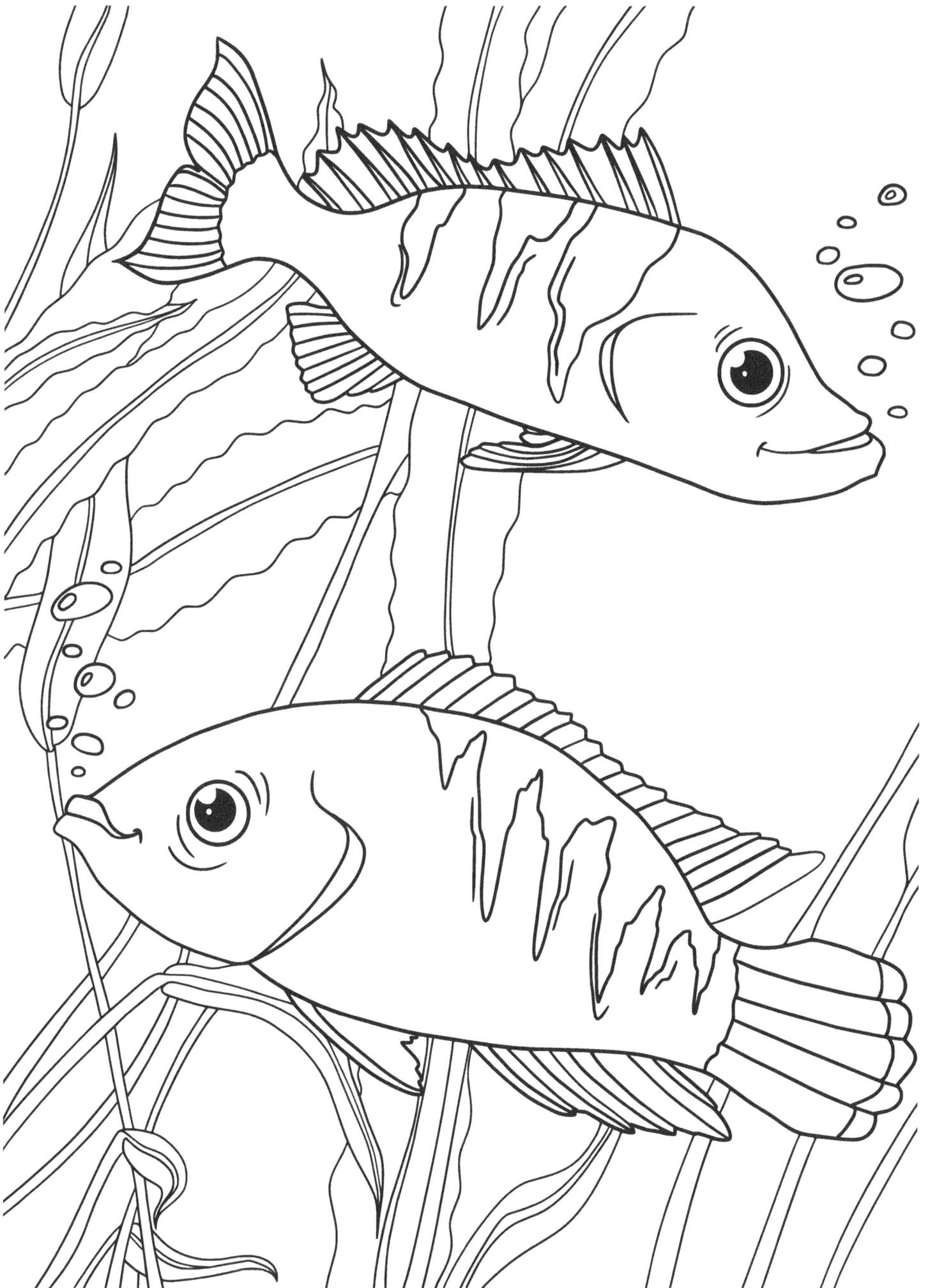

# Do You Know
# Who I Am ?

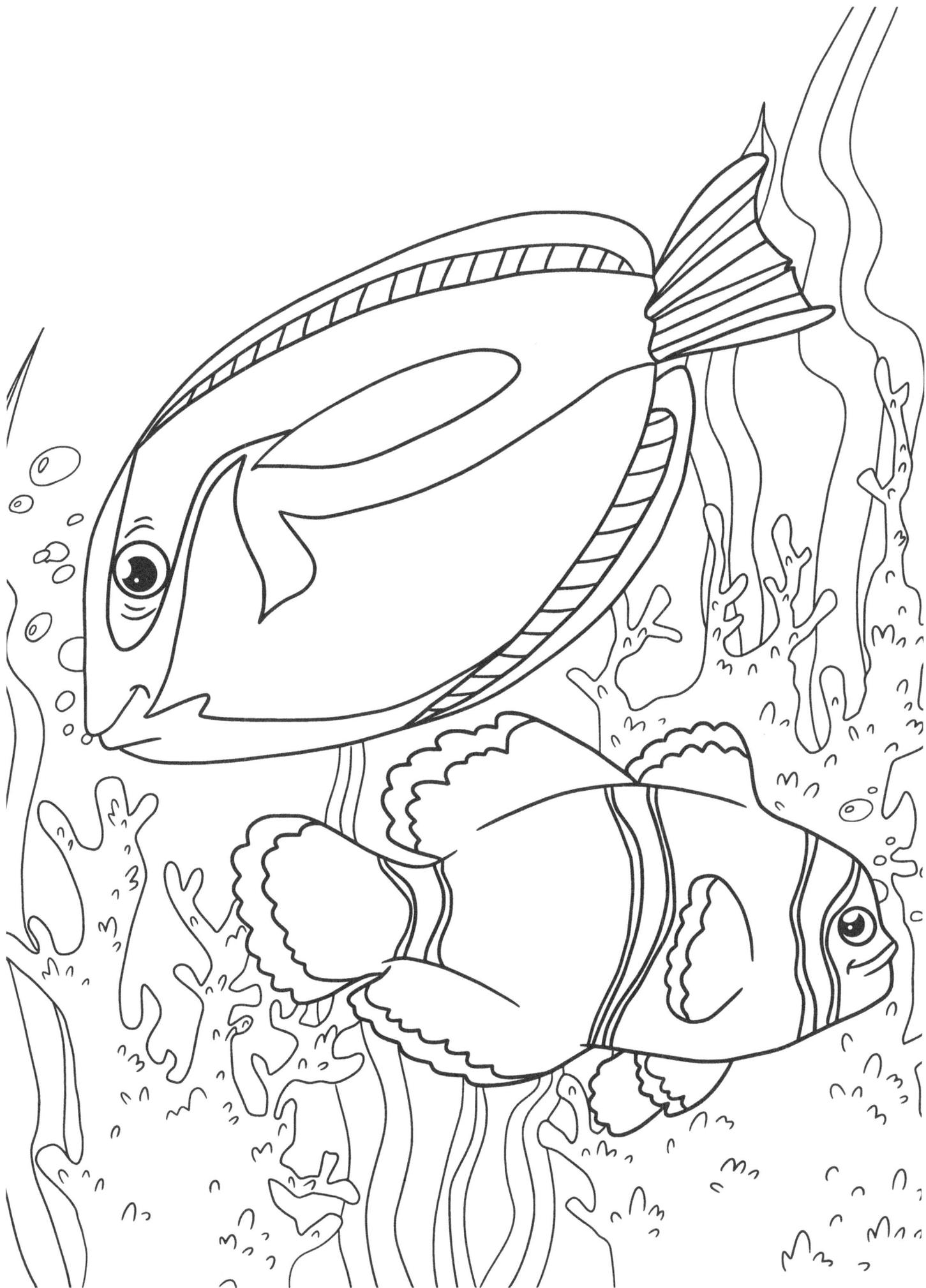

# Do You Know Who I Am ?

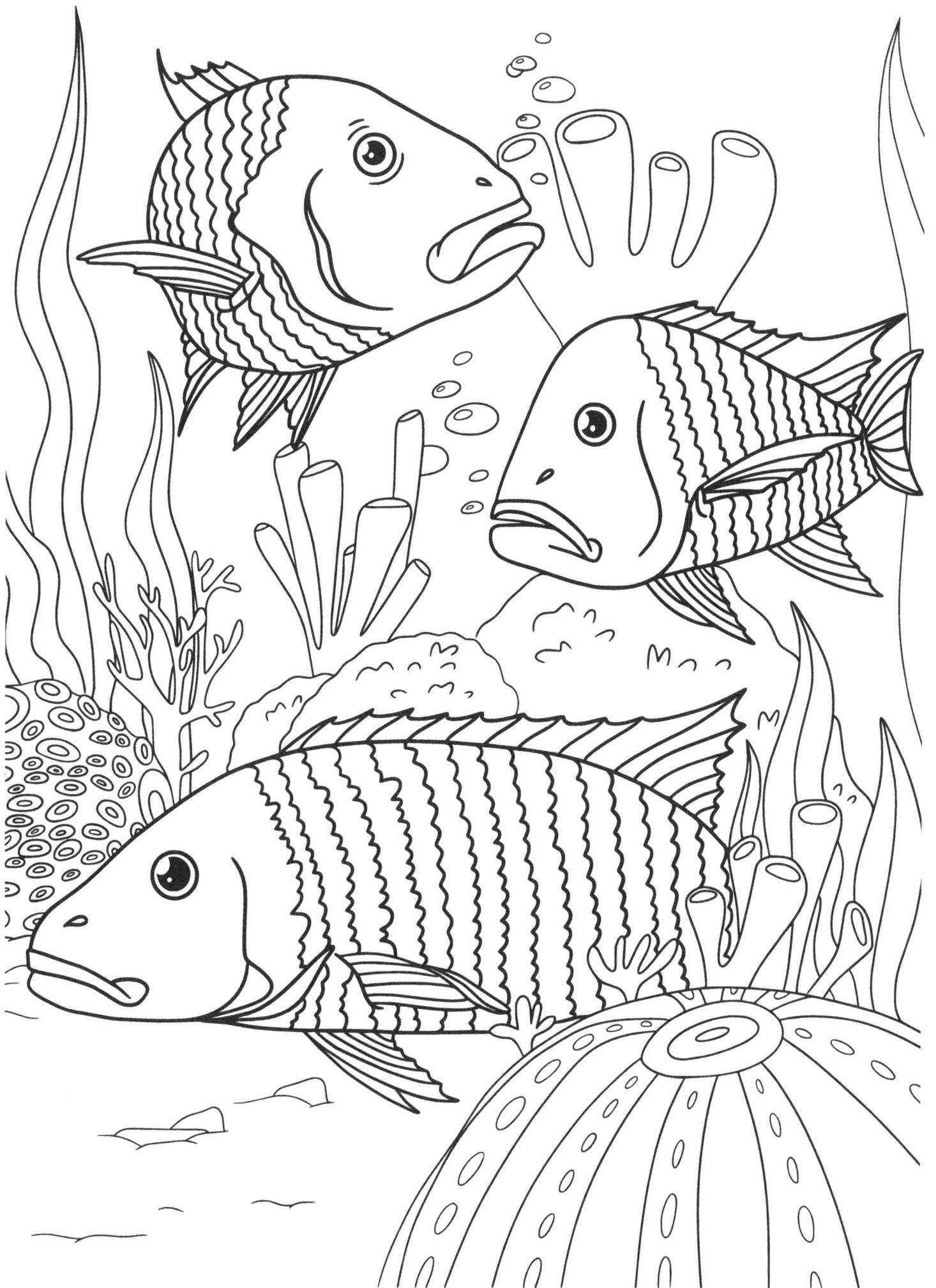

# Do You Know Who I Am ?

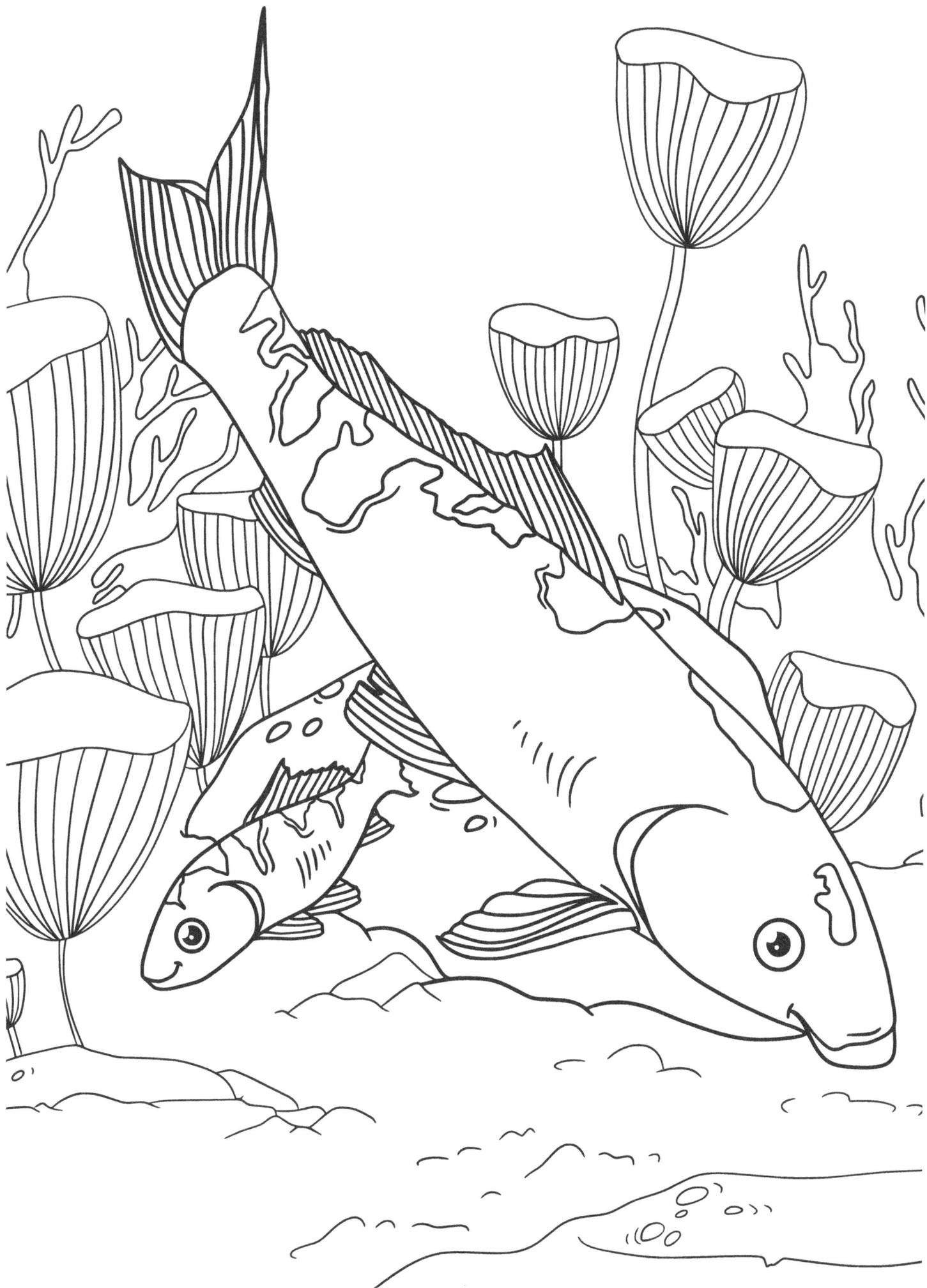

# Do You Know Who I Am ?

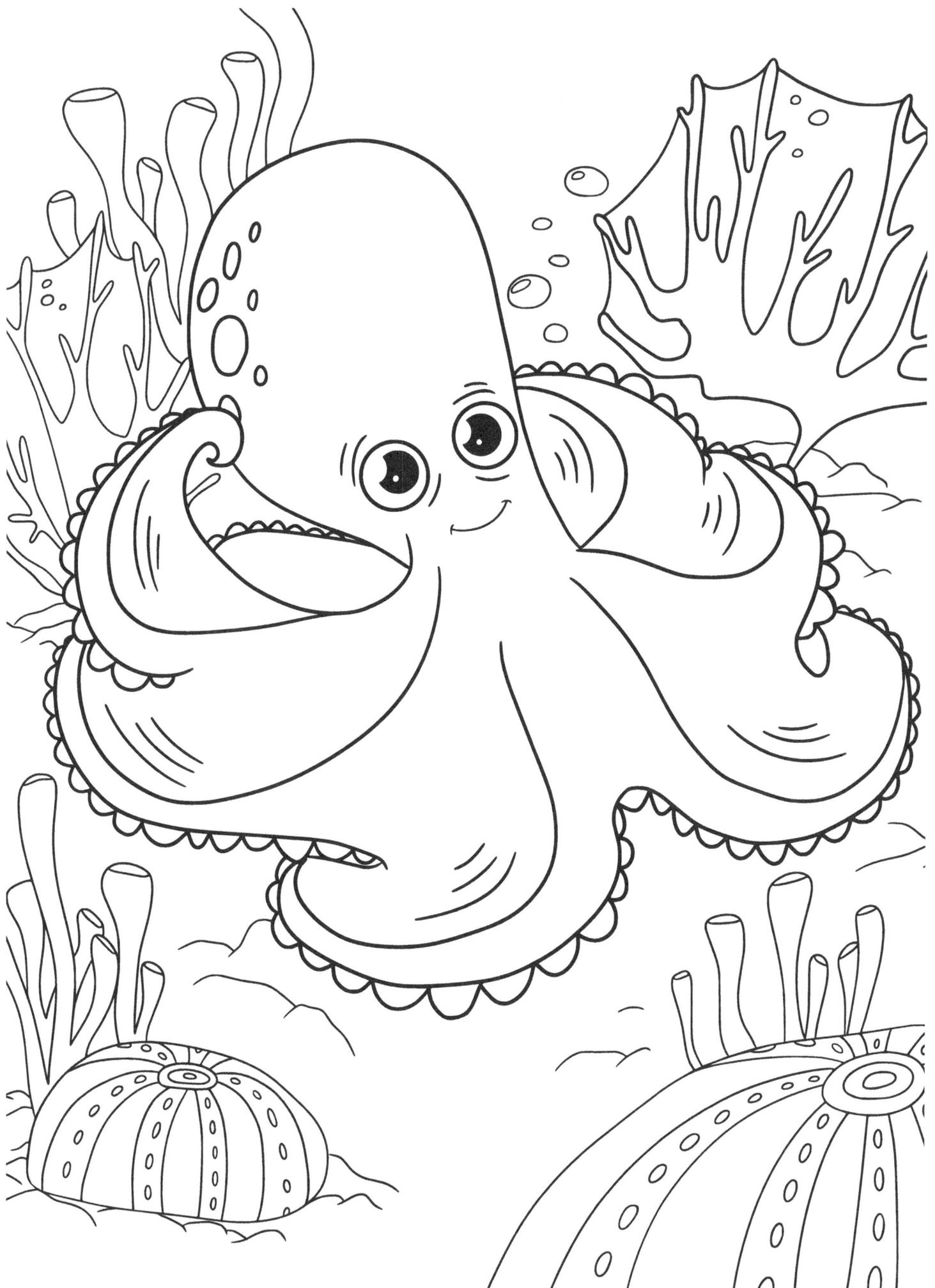

# Do You Know Who I Am ?

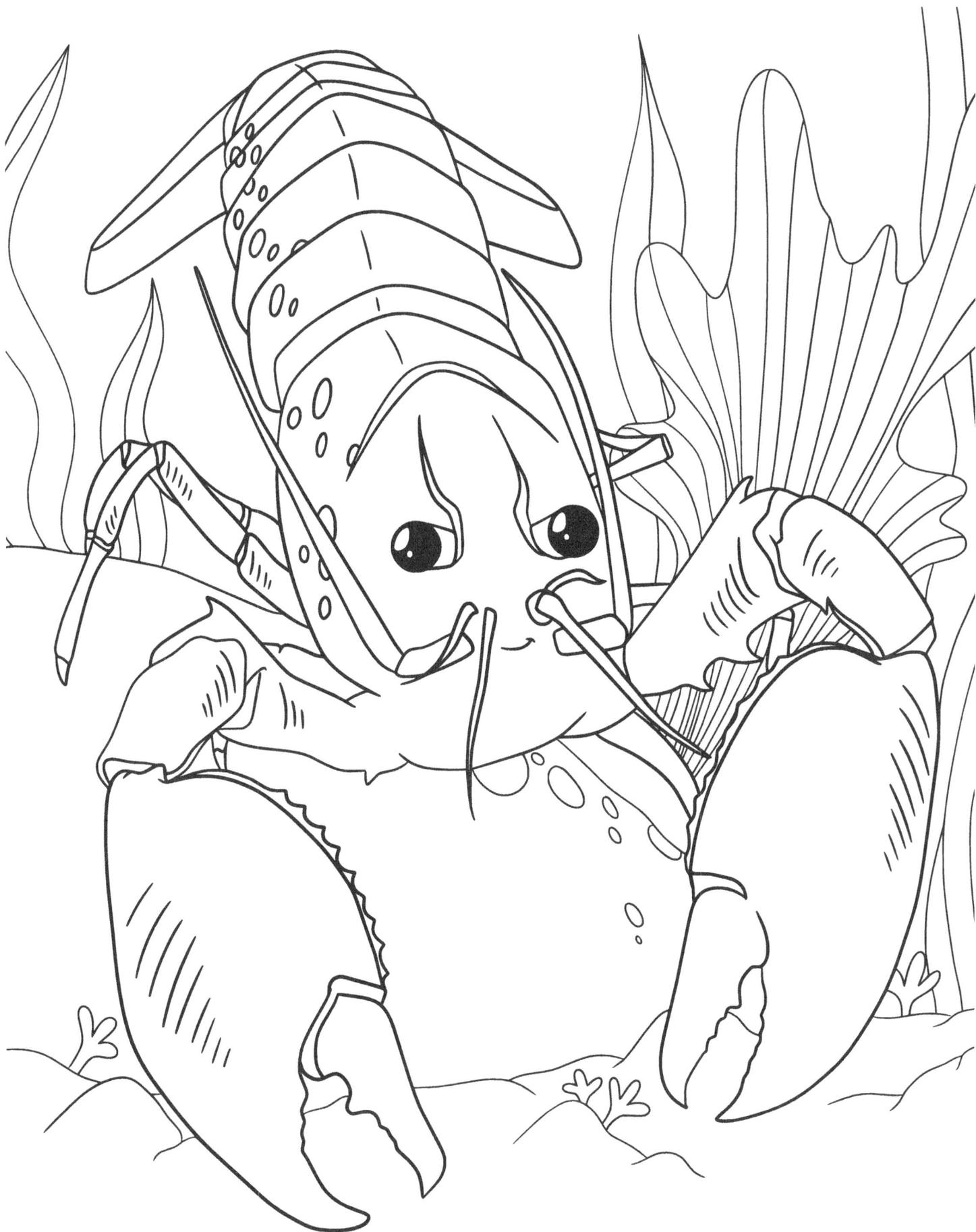

# Do You Know Who I Am ?

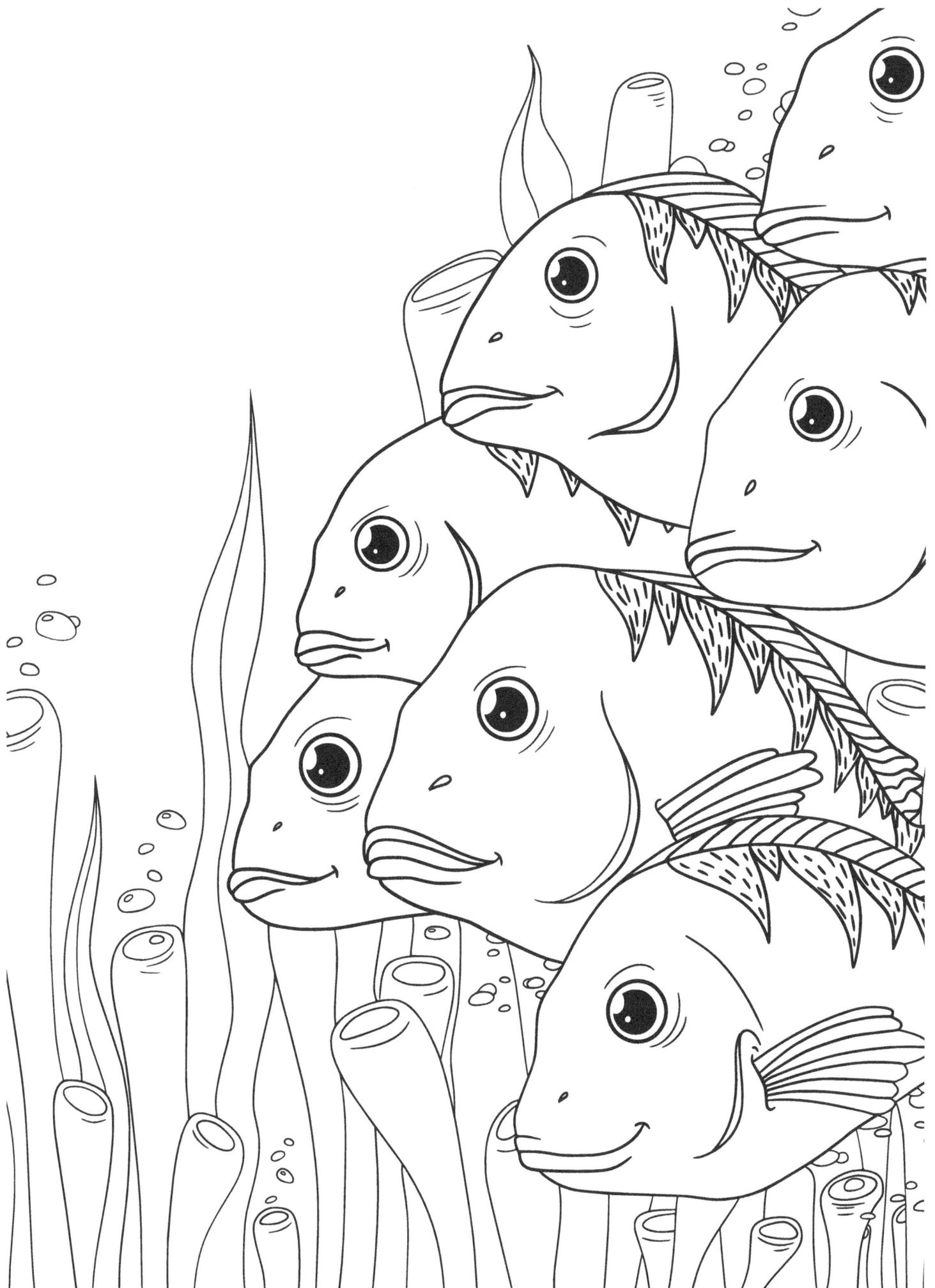

# Do You Know Who I Am ?

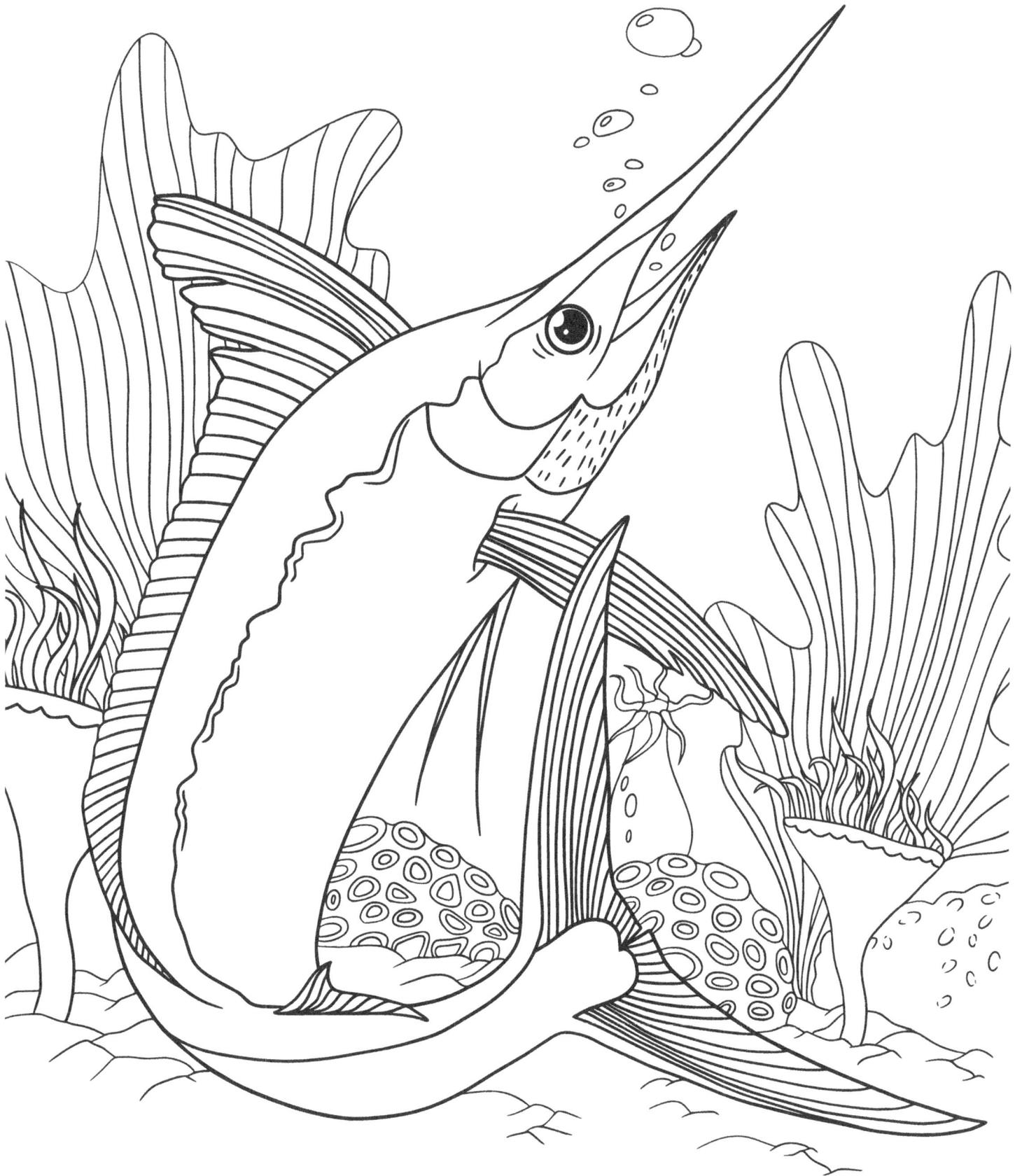

# Do You Know Who I Am ?

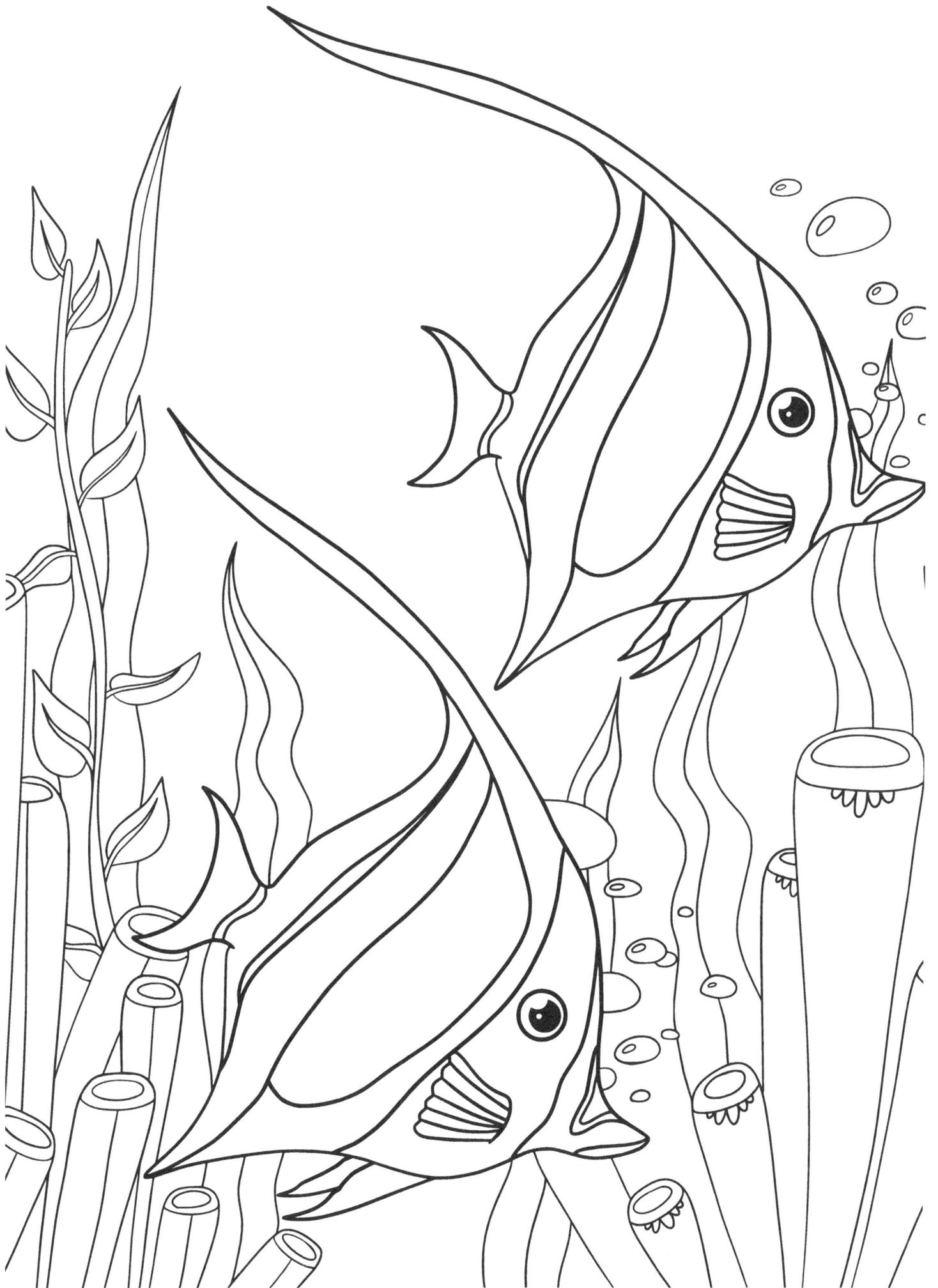

# Do You Know Who I Am ?

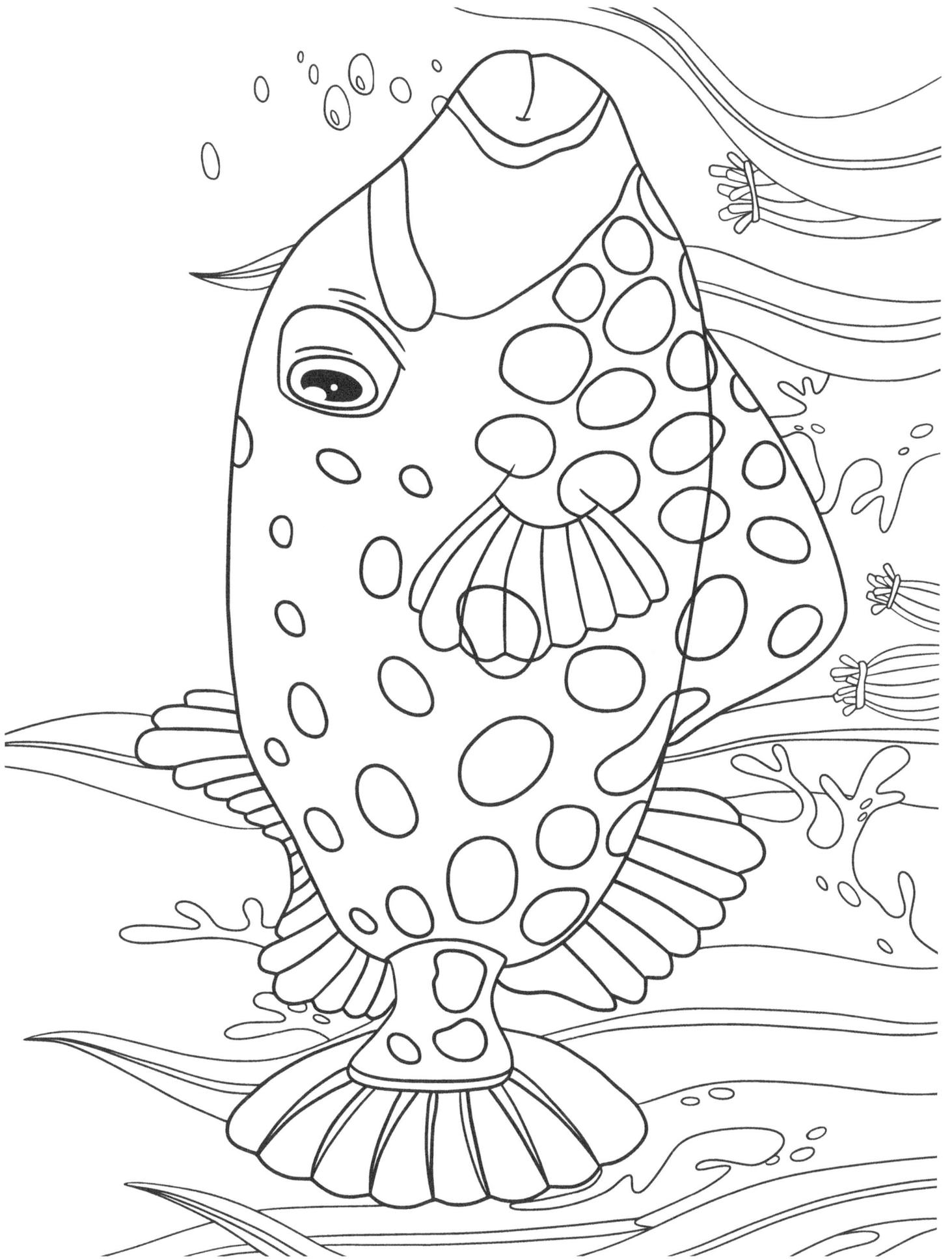

# Do You Know Who I Am ?

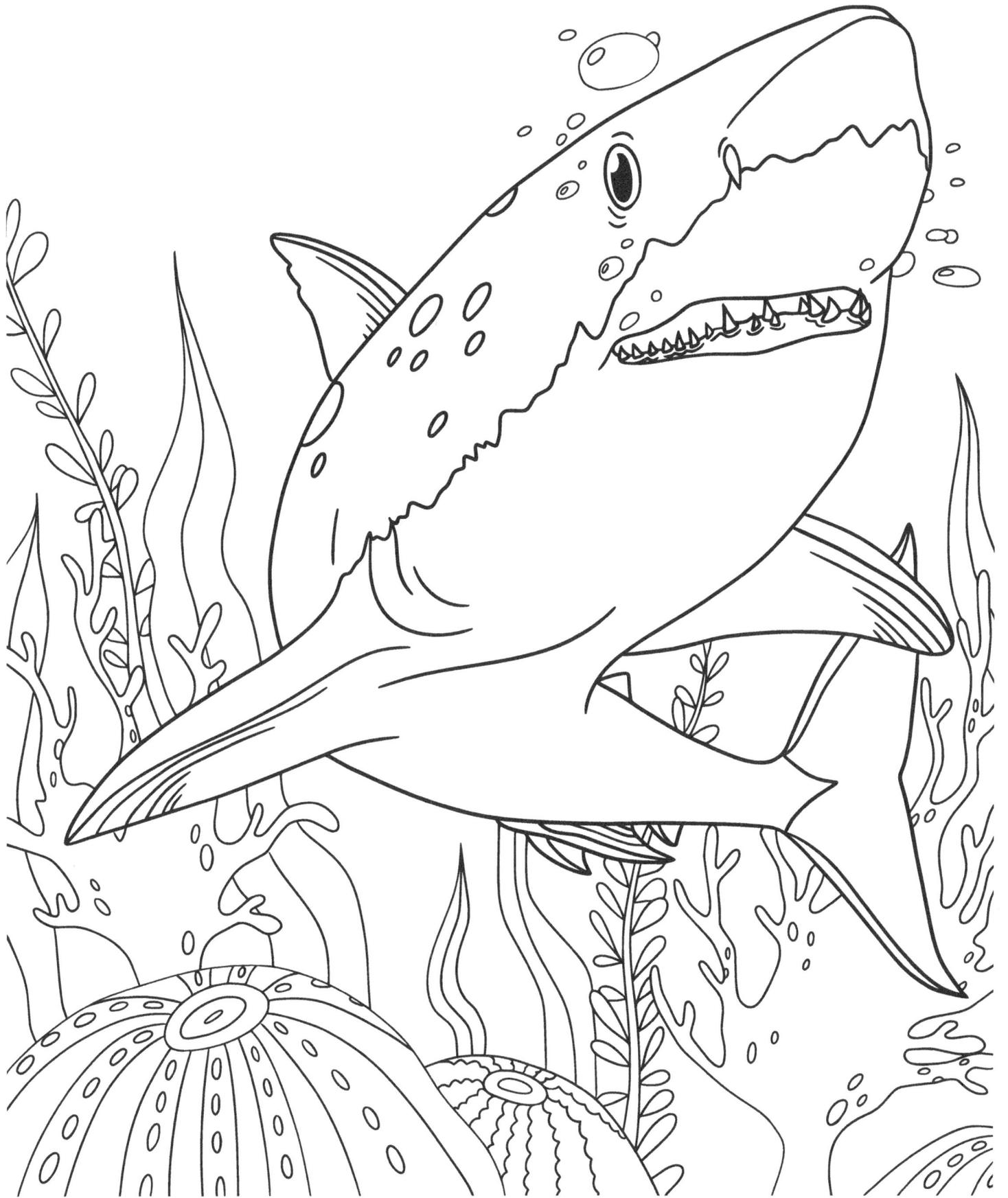

# Do You Know Who I Am ?

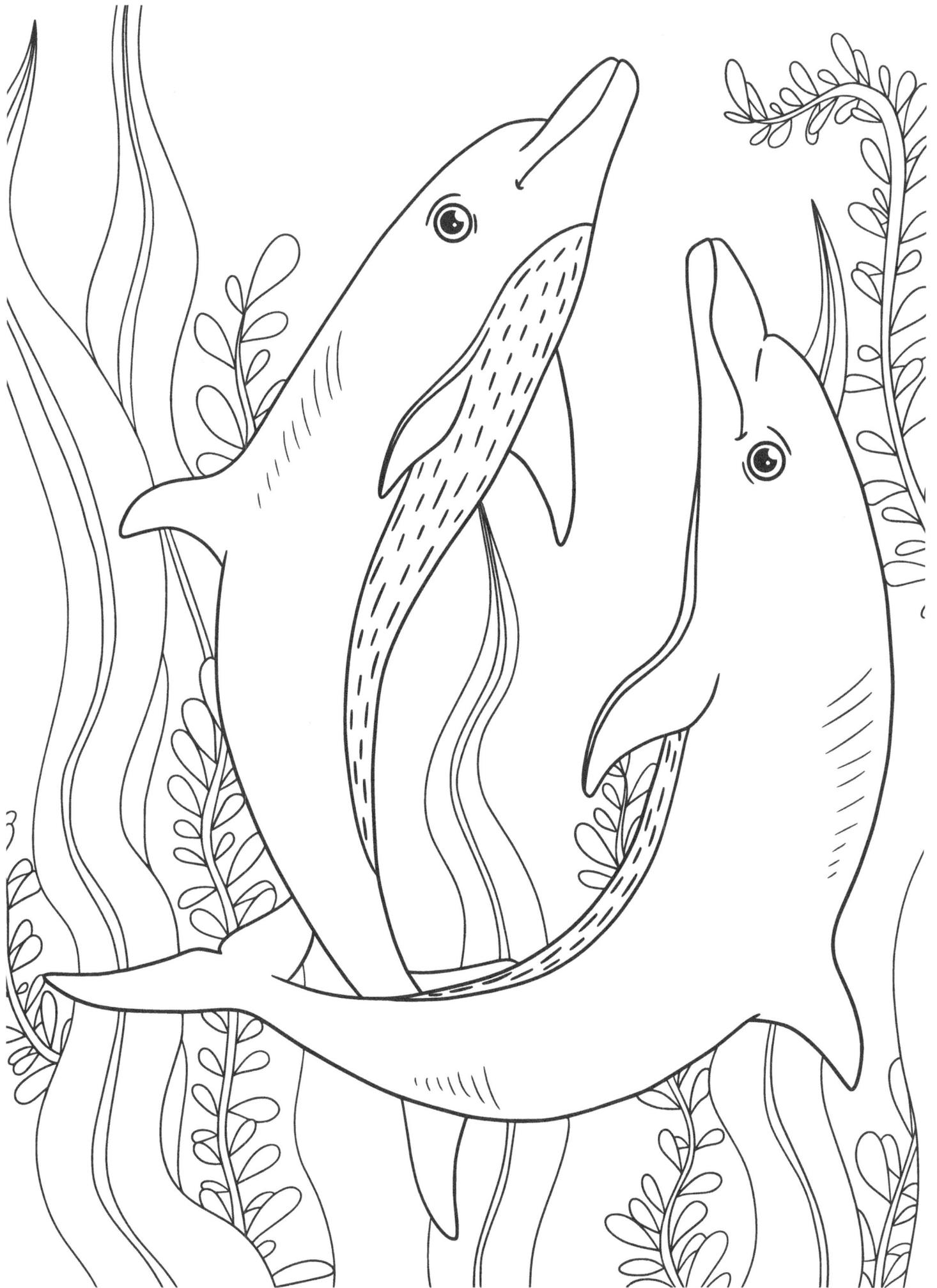

# Do You Know Who I Am ?

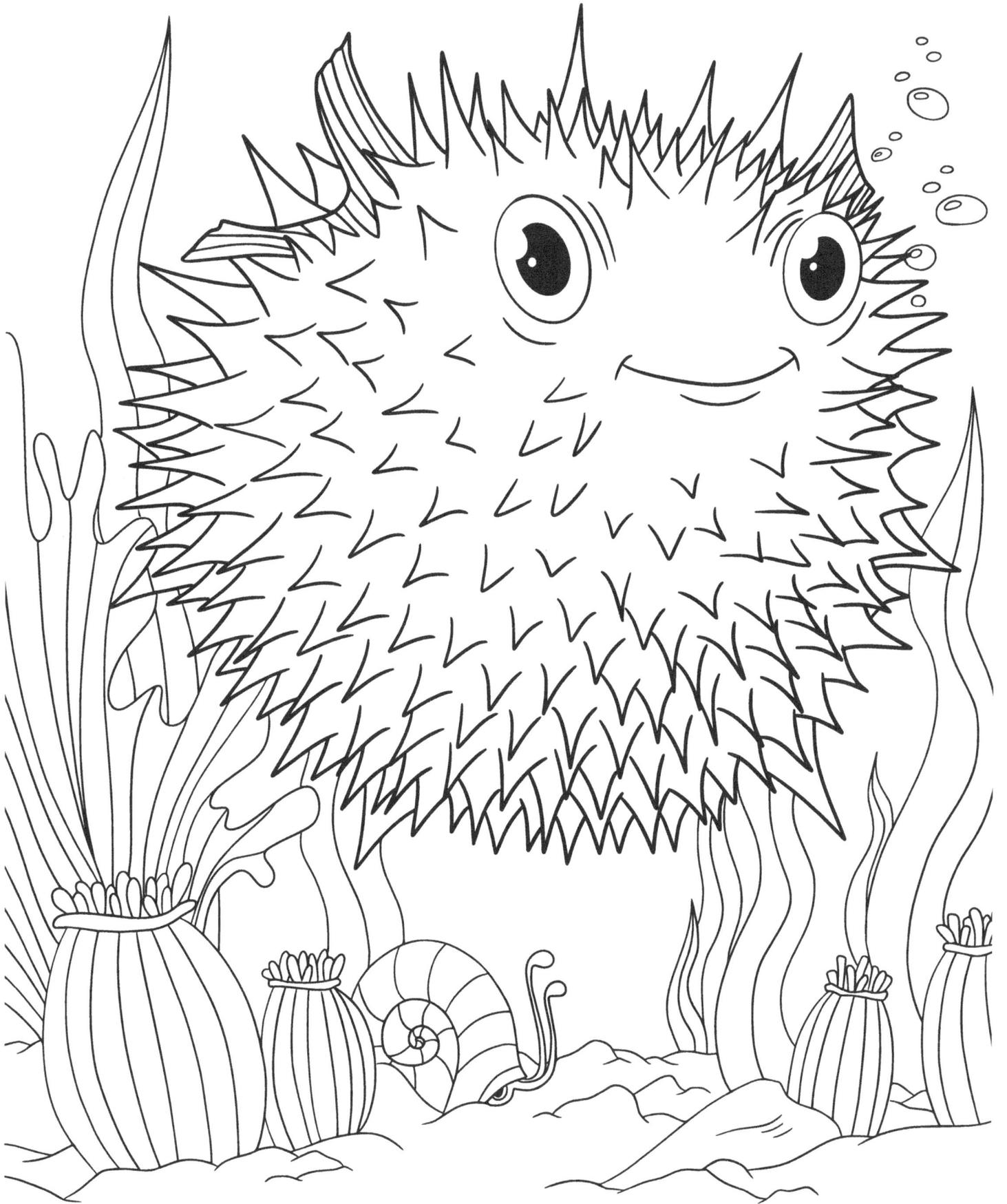

# Do You Know
# Who I Am ?

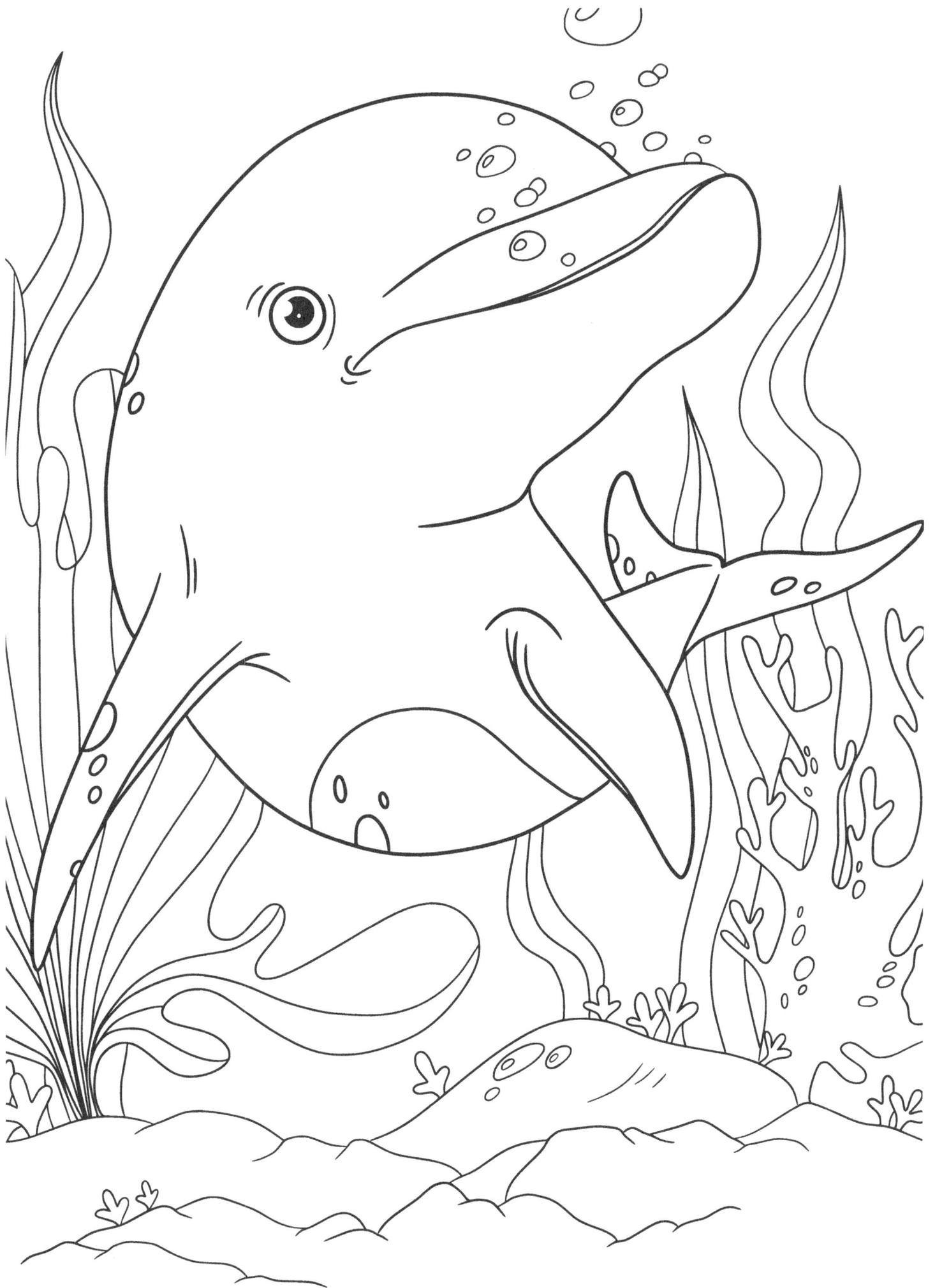

# Do You Know Who I Am ?

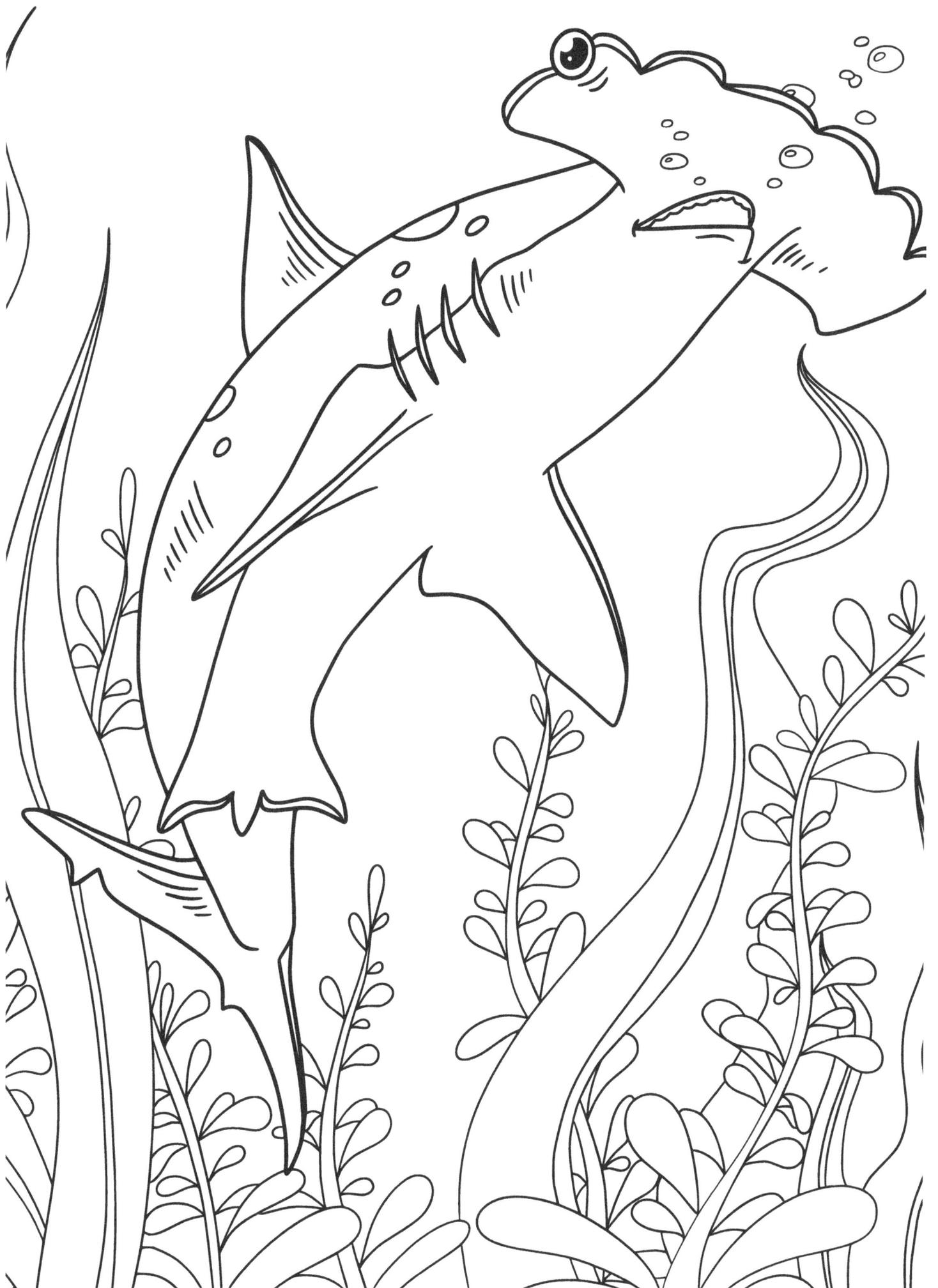

# Do You Know Who I Am ?

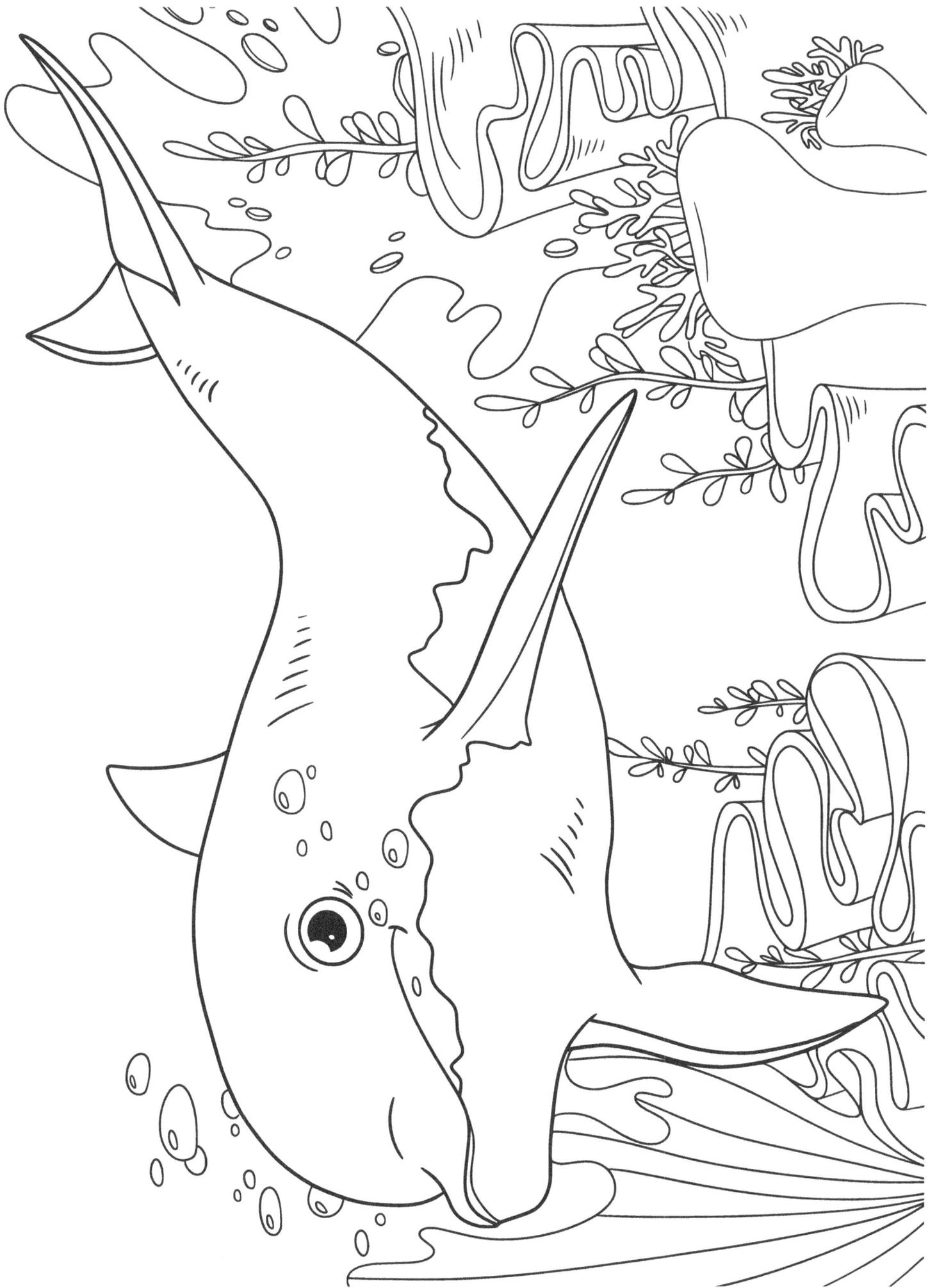

# Do You Know Who I Am ?

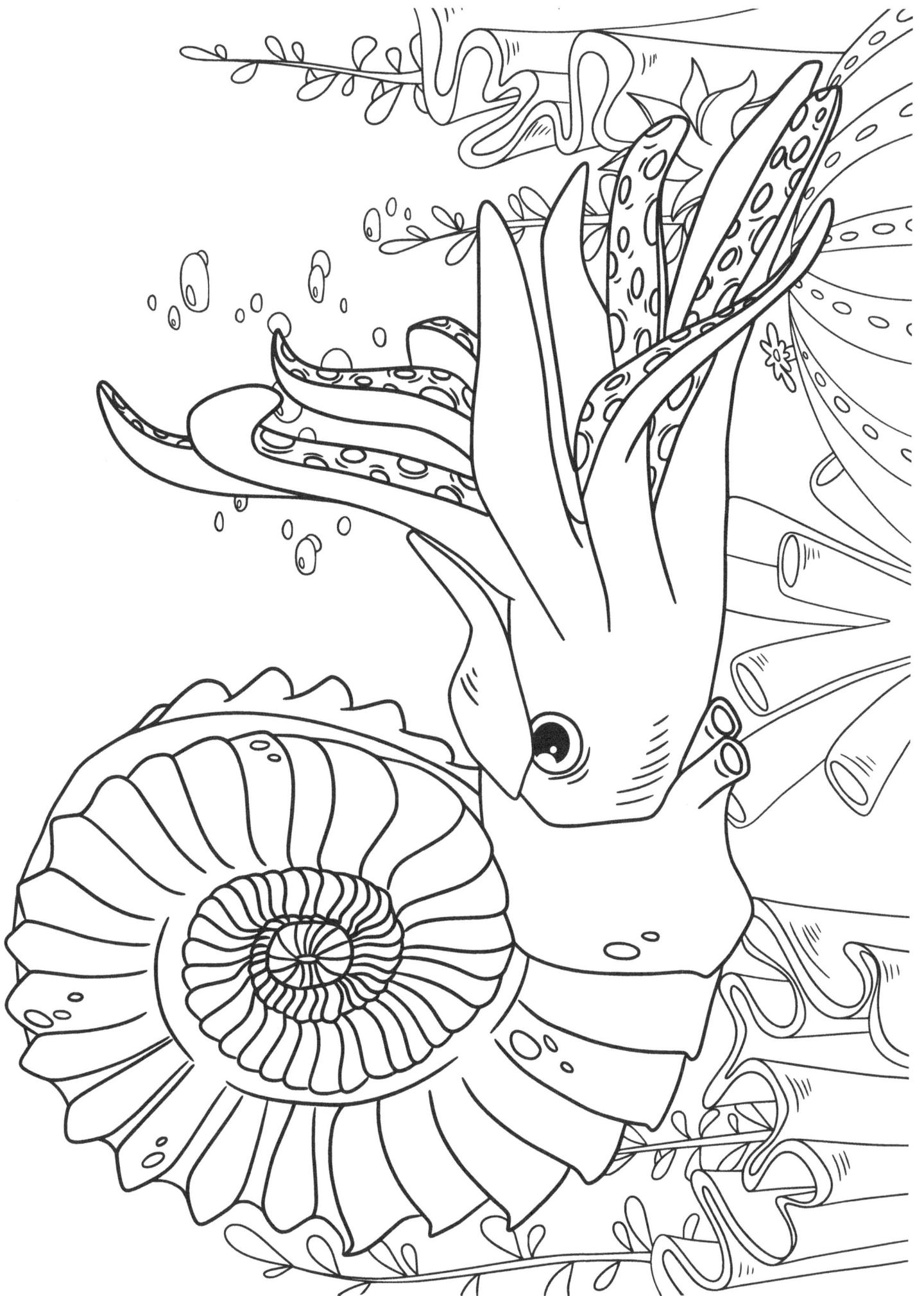

# Do You Know Who I Am ?

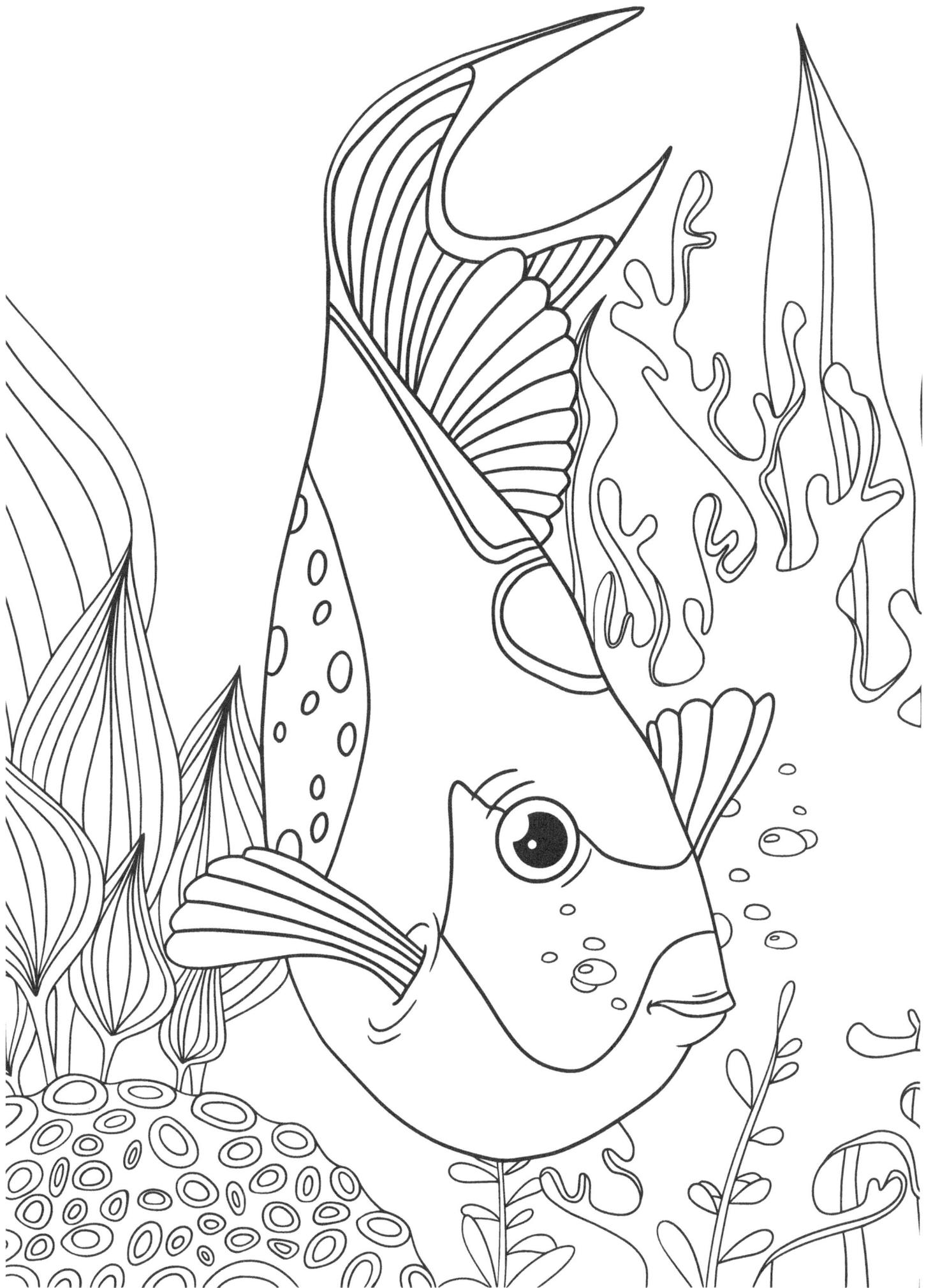

# Do You Know Who I Am ?

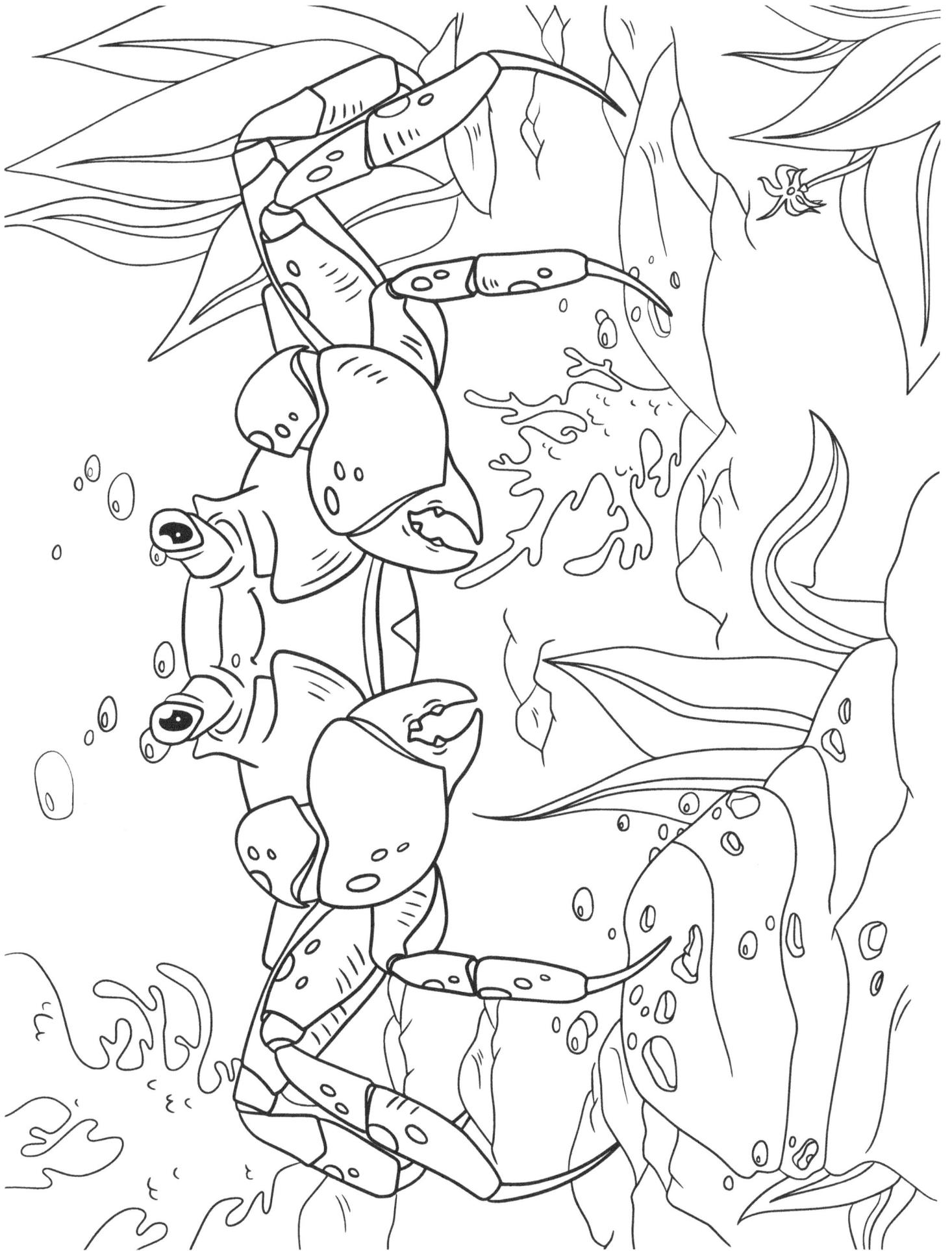

# Do You Know Who I Am ?

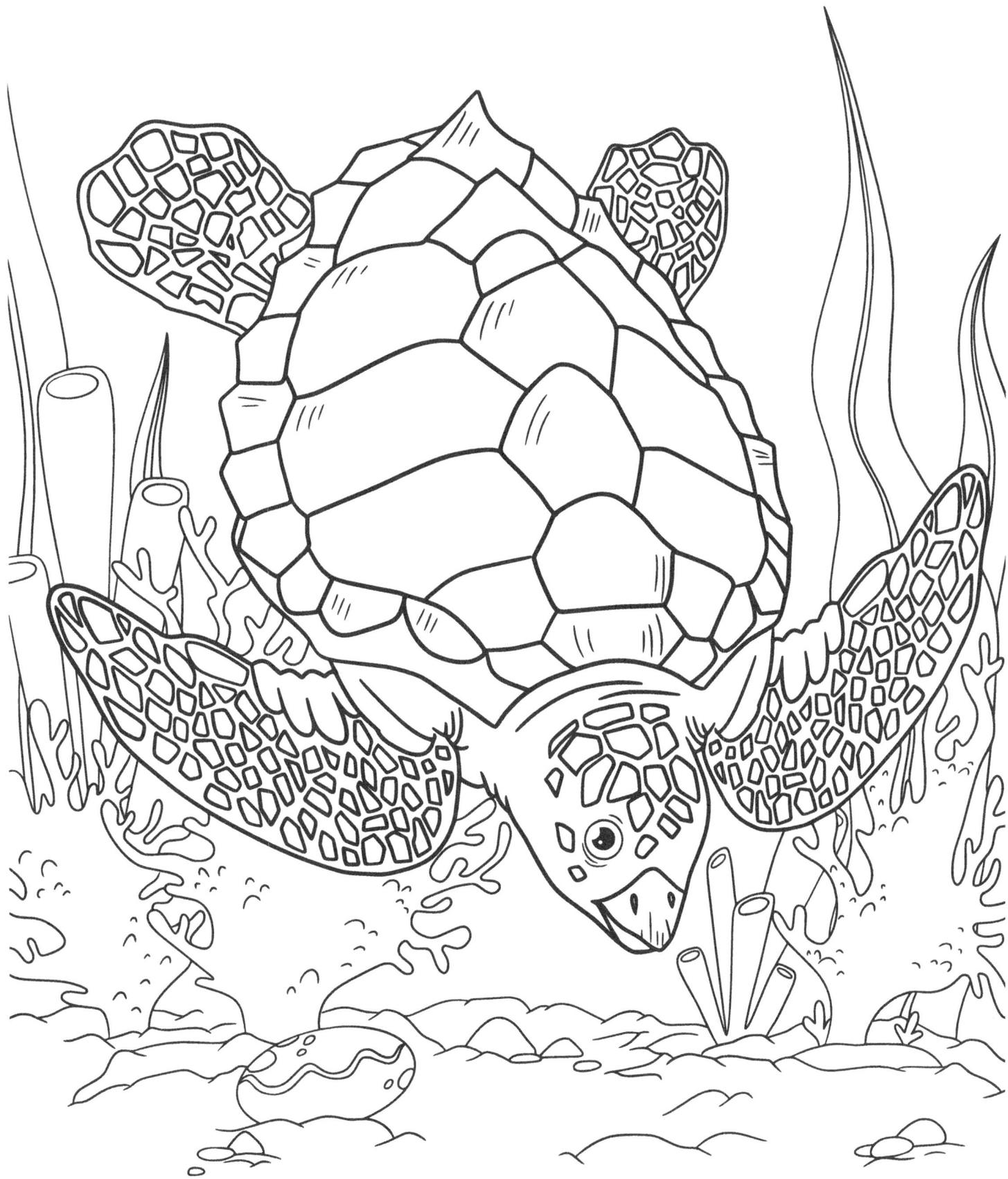

# Do You Know Who I Am ?

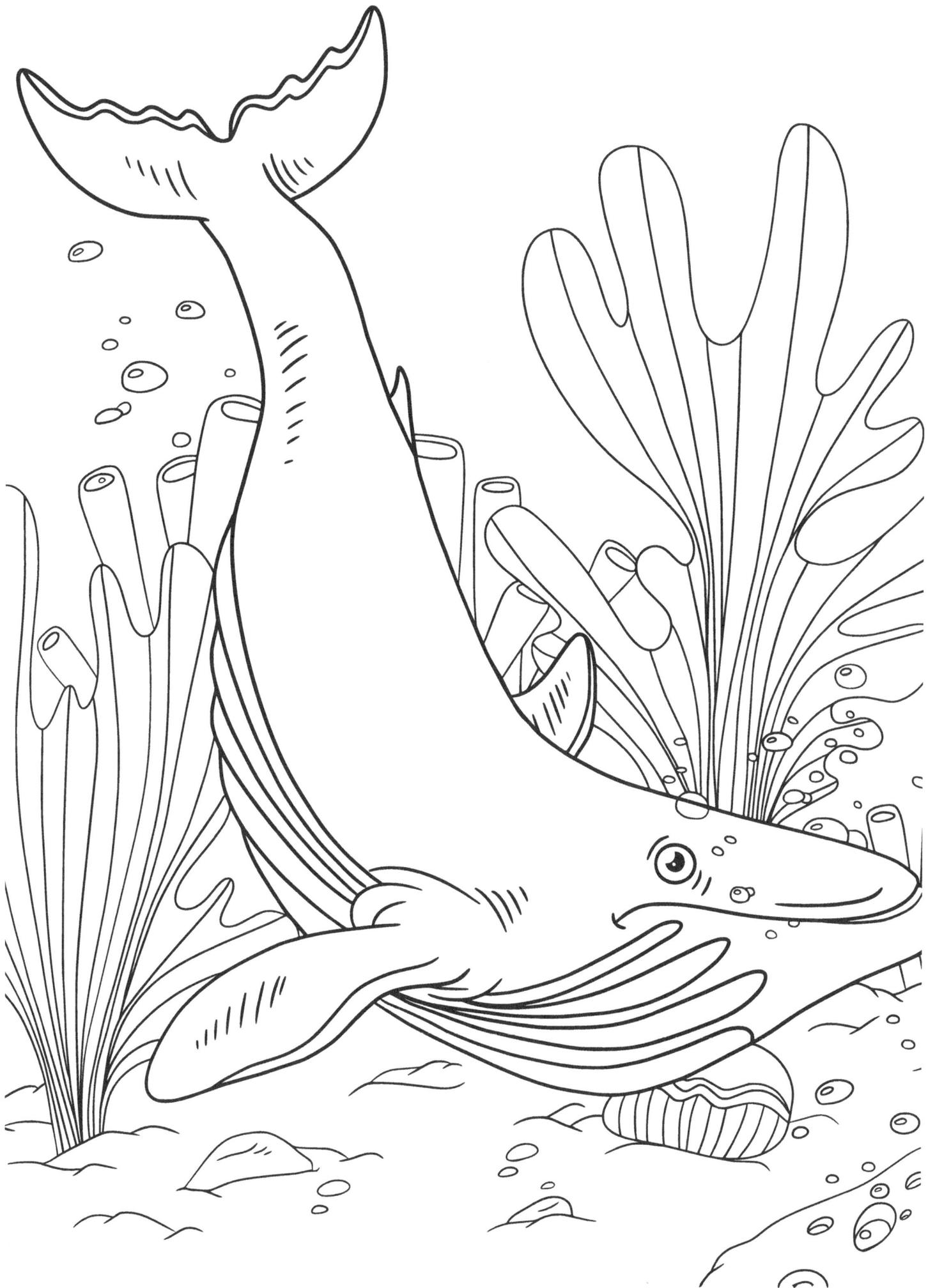

# Do You Know Who I Am ?

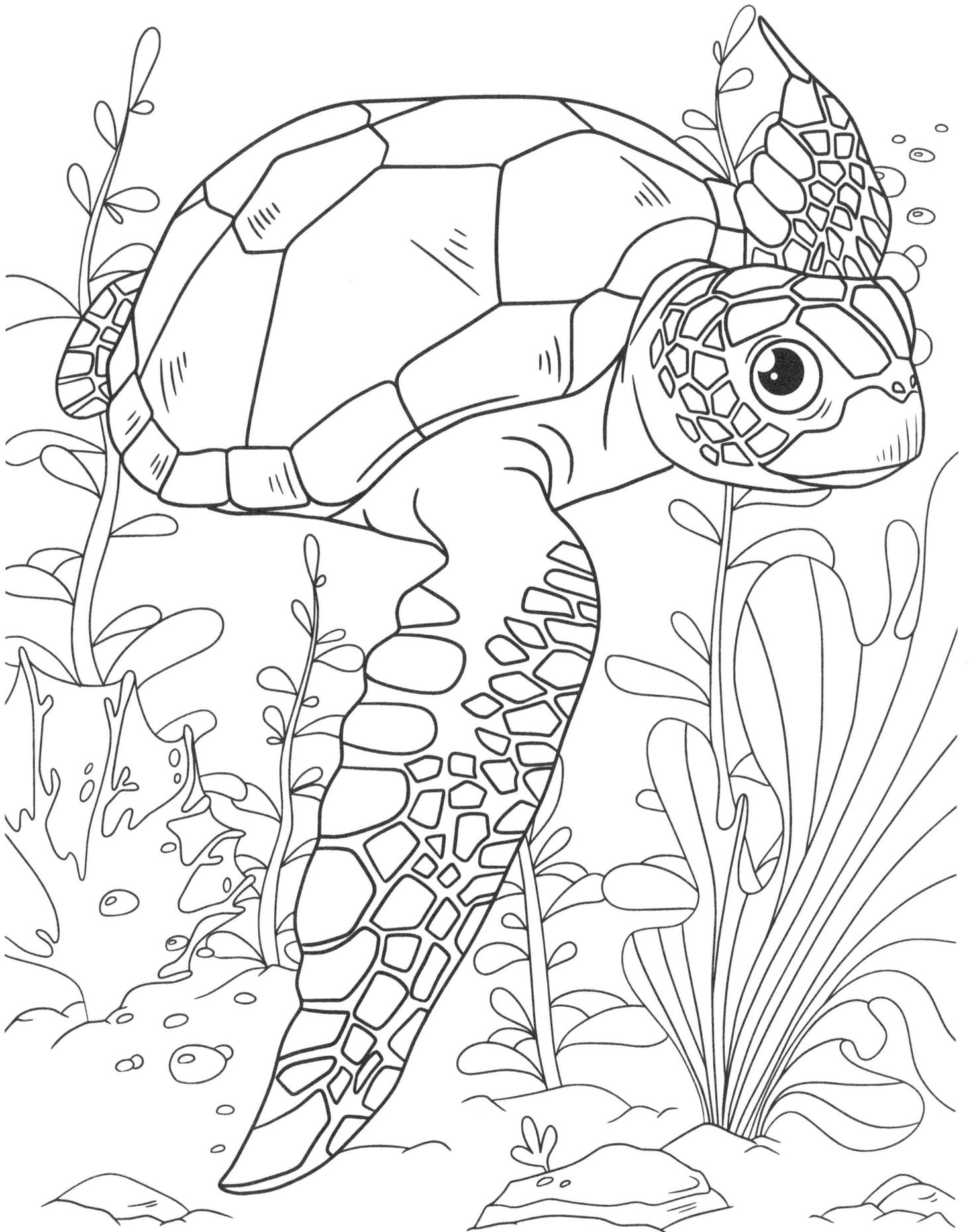

# Do You Know Who I Am ?

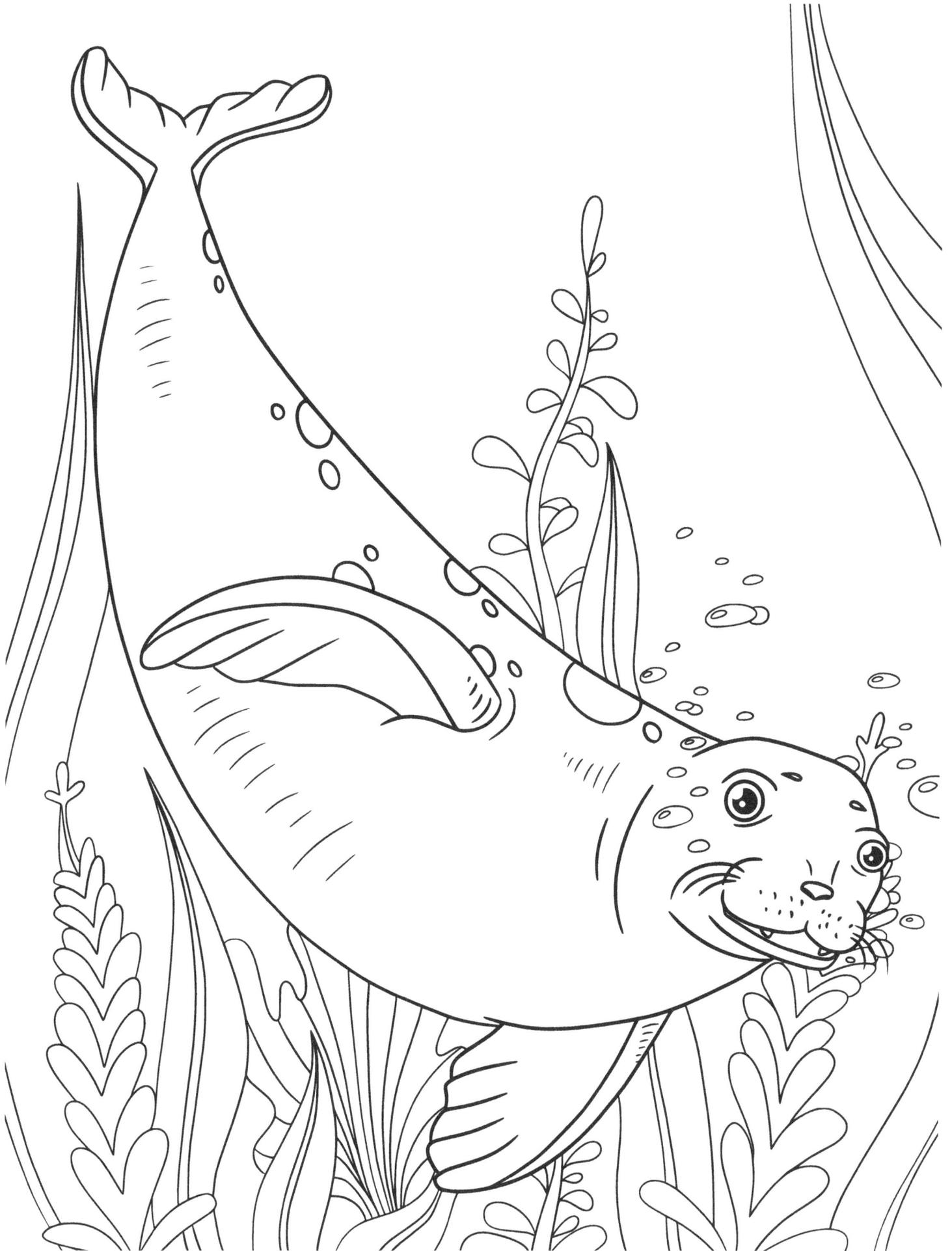

# Do You Know Who I Am ?

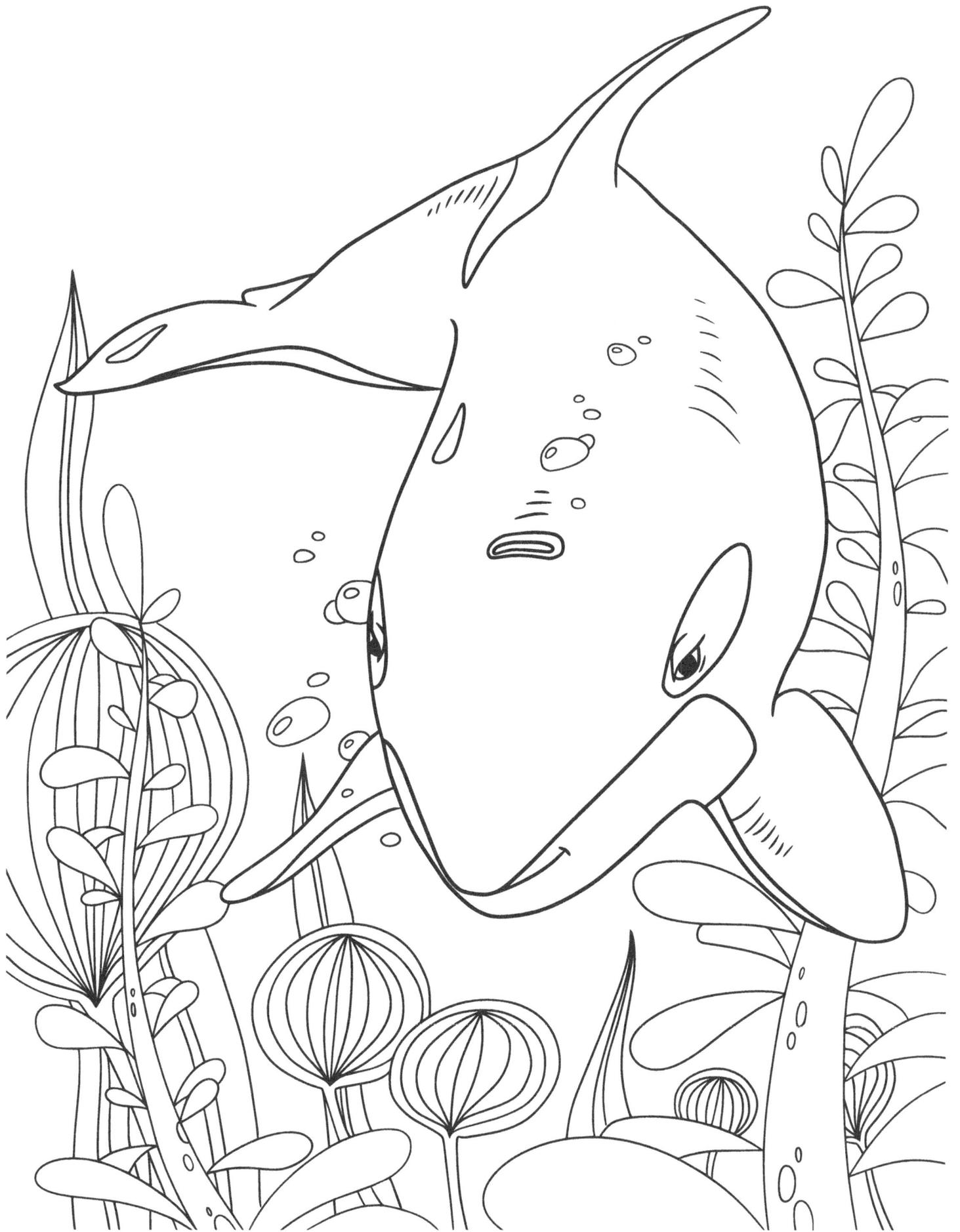

# Do You Know Who I Am ?

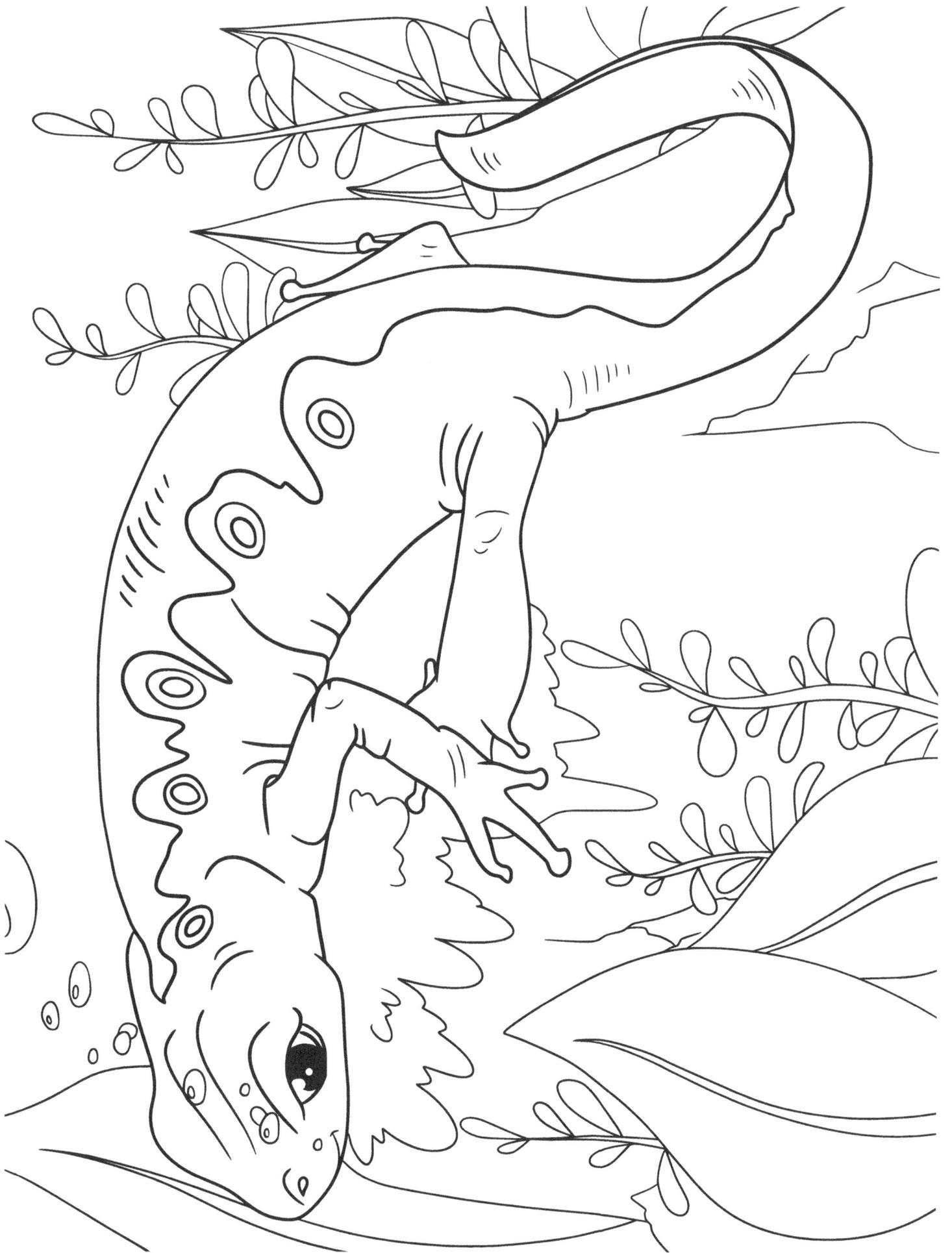

# Do You Know Who I Am ?

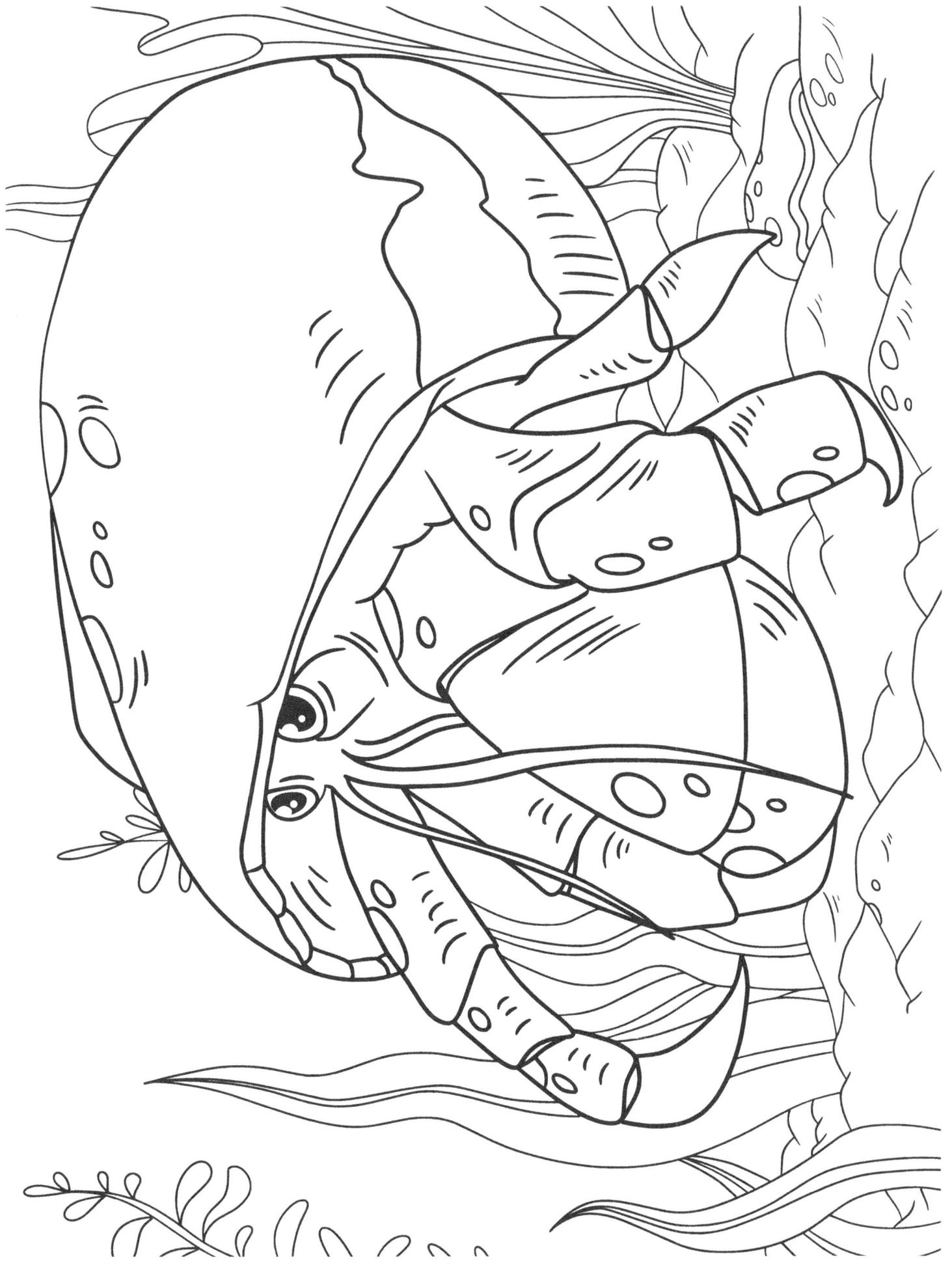

# Do You Know Who I Am ?

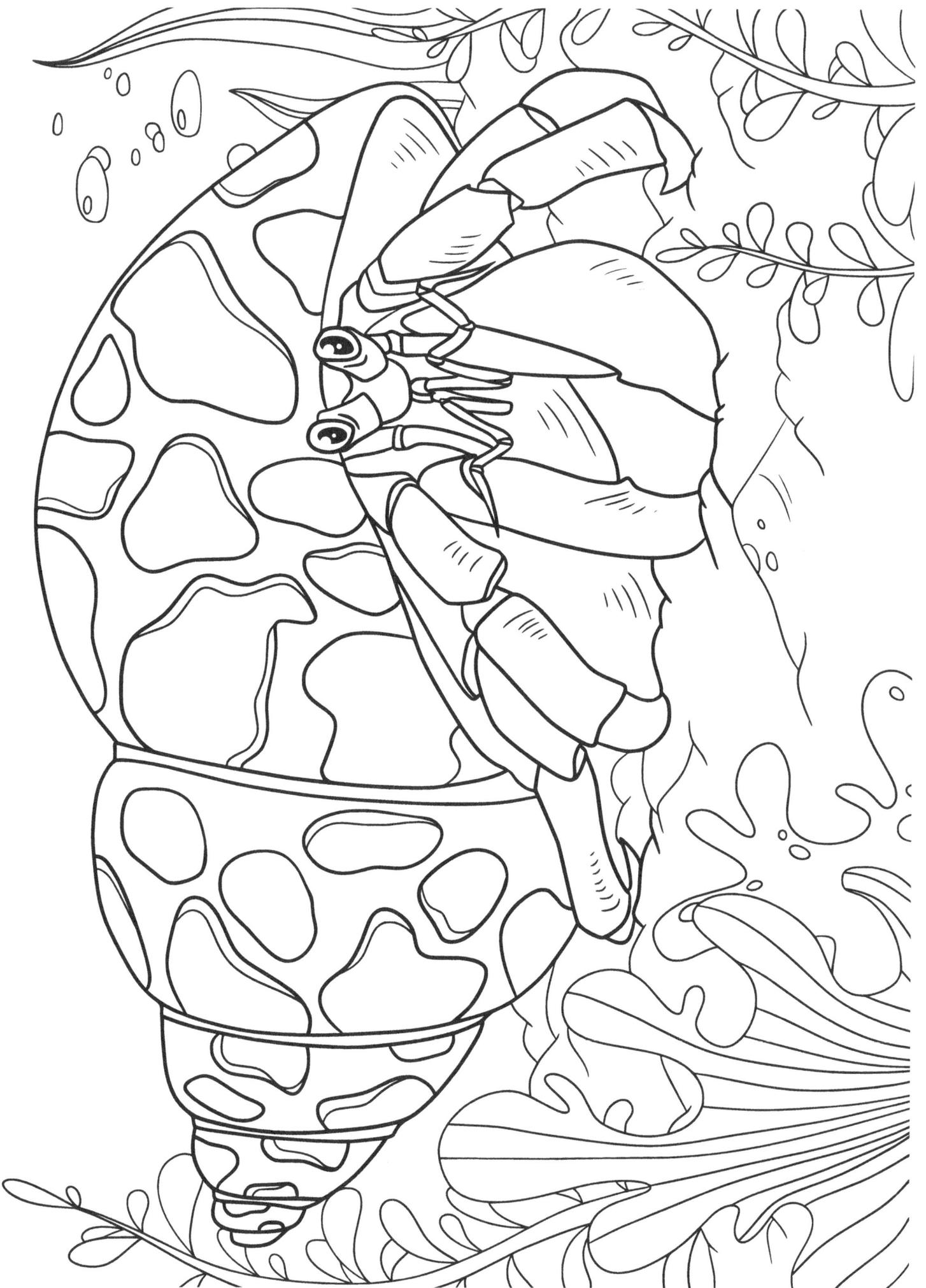

# Do You Know Who I Am ?

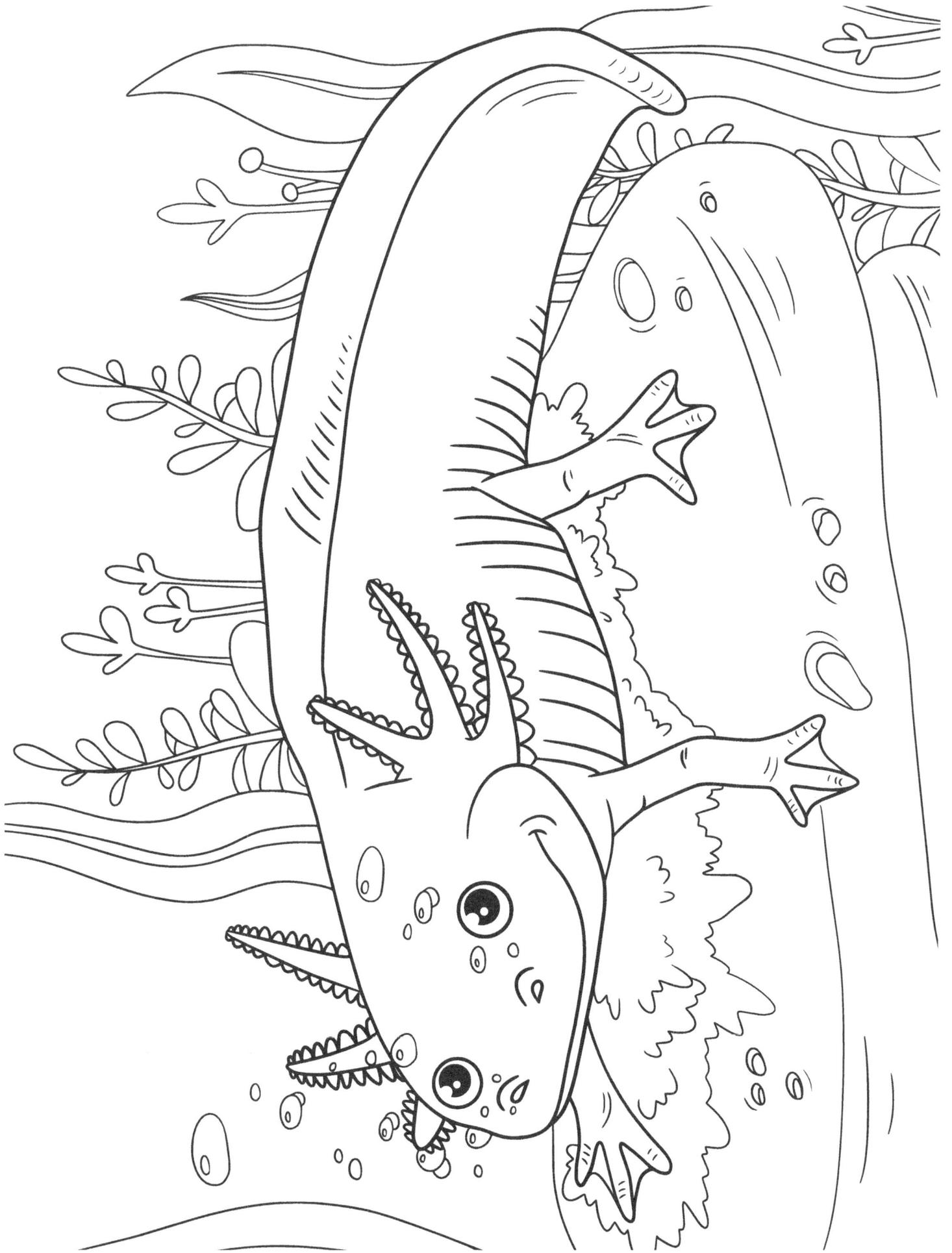

# Do You Know Who I Am ?

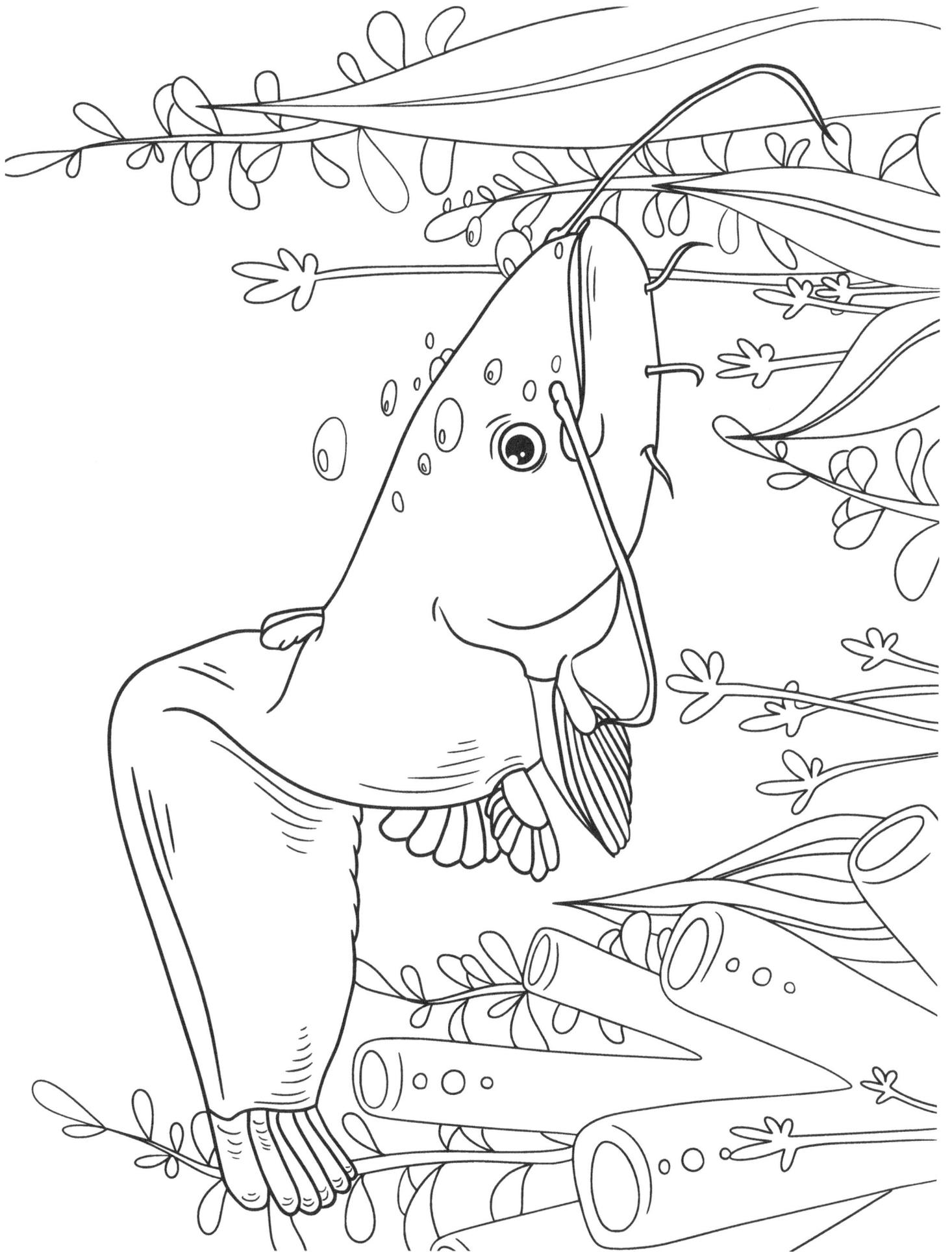

# Do You Know Who I Am ?

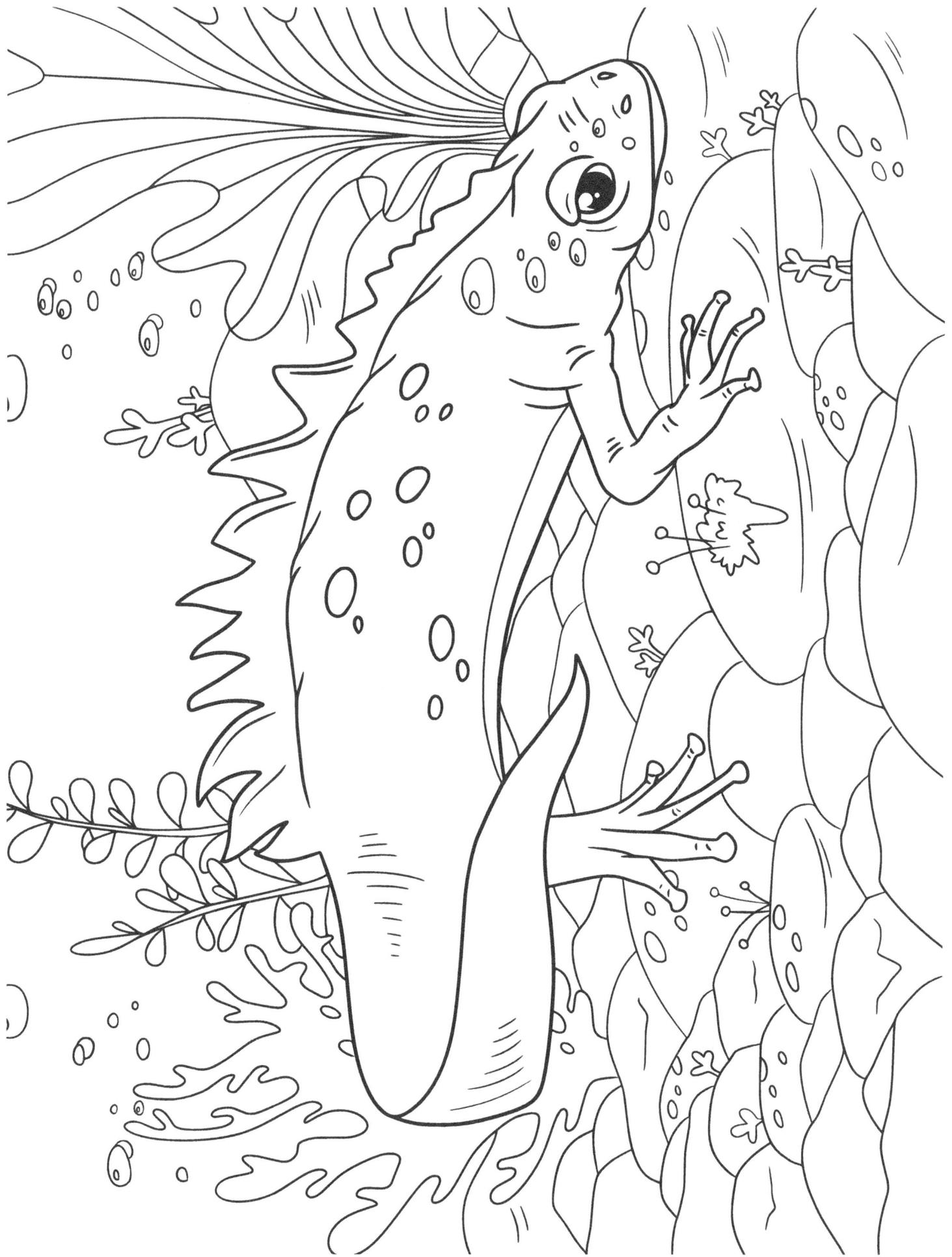

# Do You Know Who I Am ?

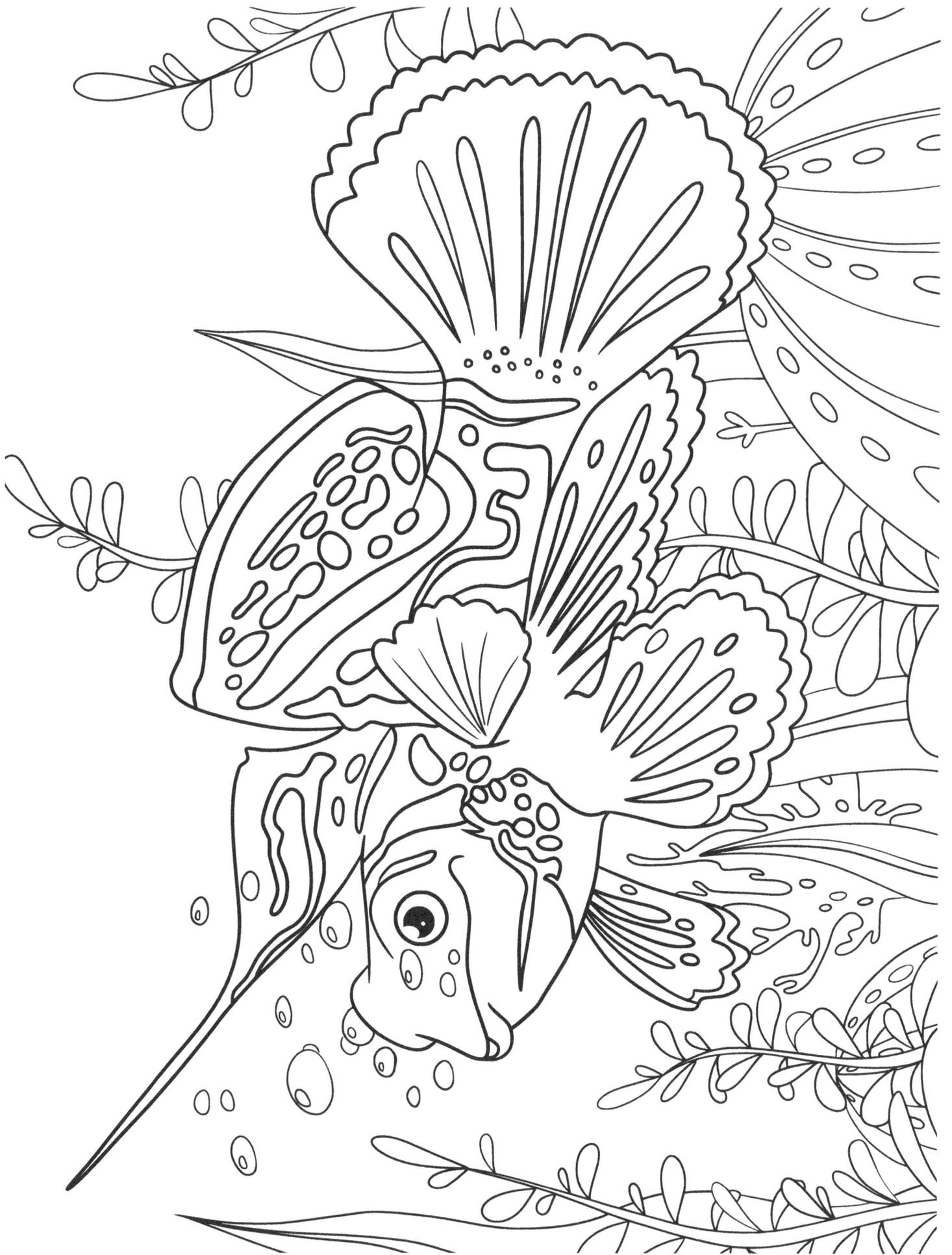

# Do You Know Who I Am ?

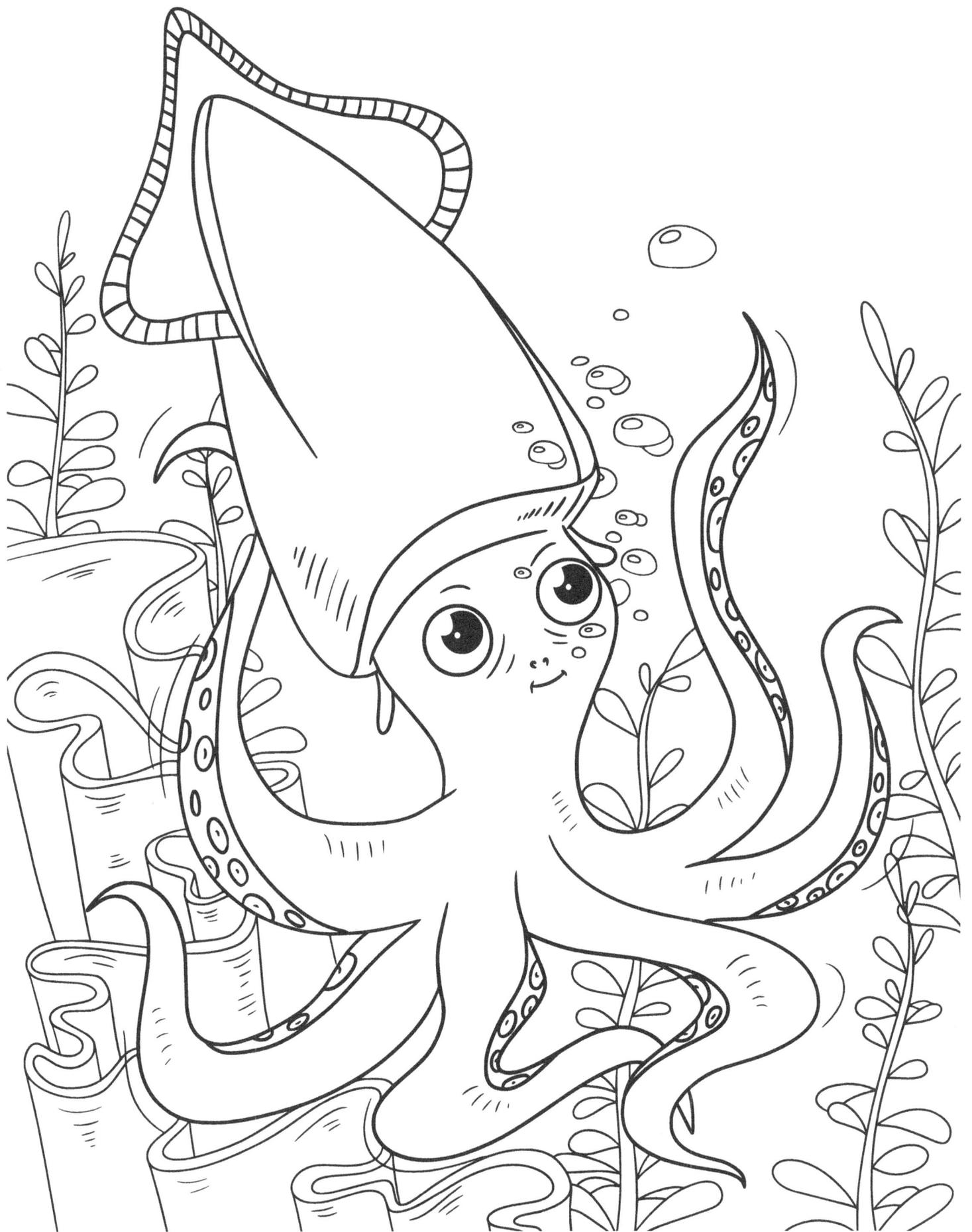

# Do You Know Who I Am ?

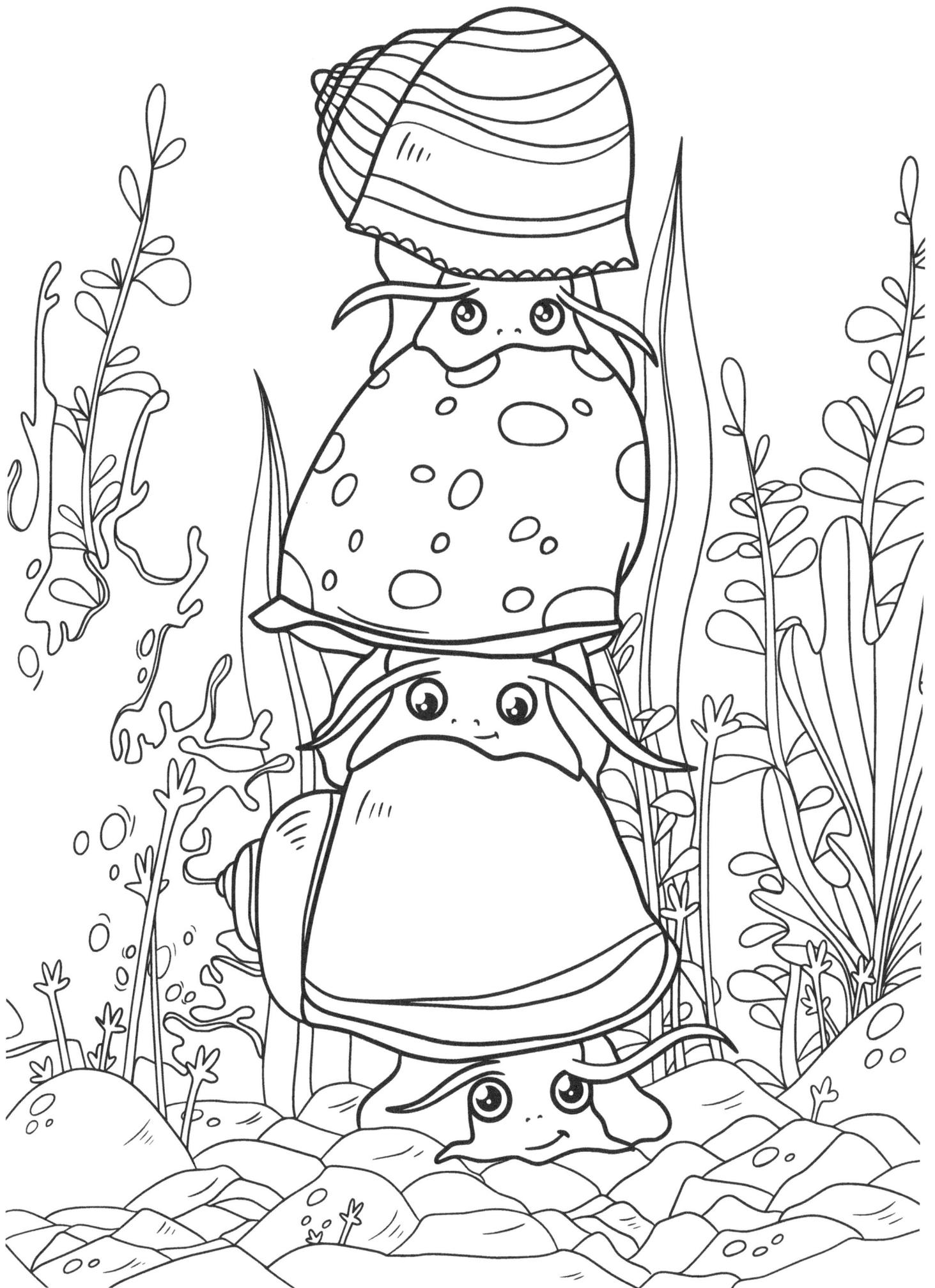

# Do You Know Who I Am ?

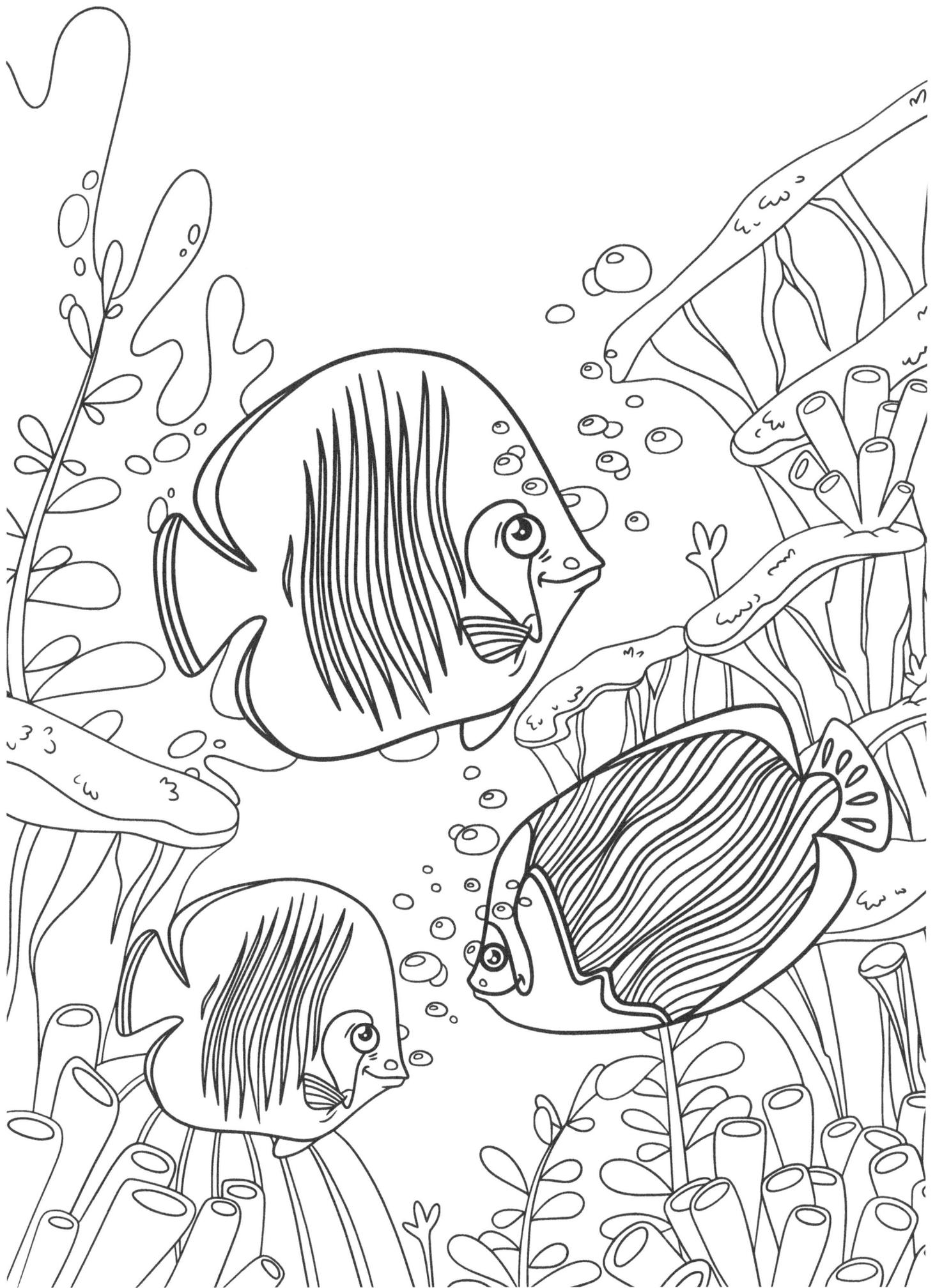

# Do You Know
# Who I Am ?

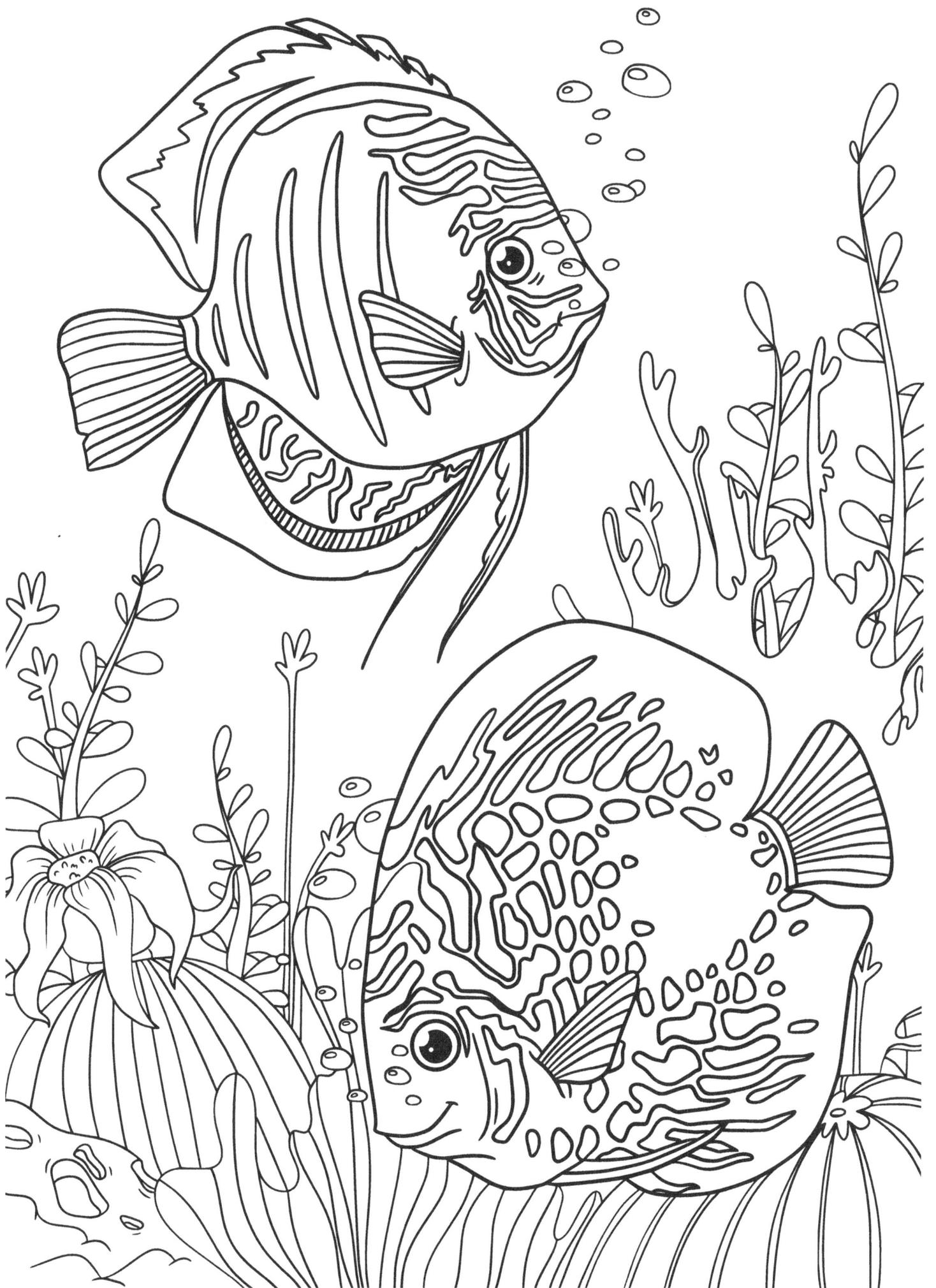

# Do You Know Who I Am ?

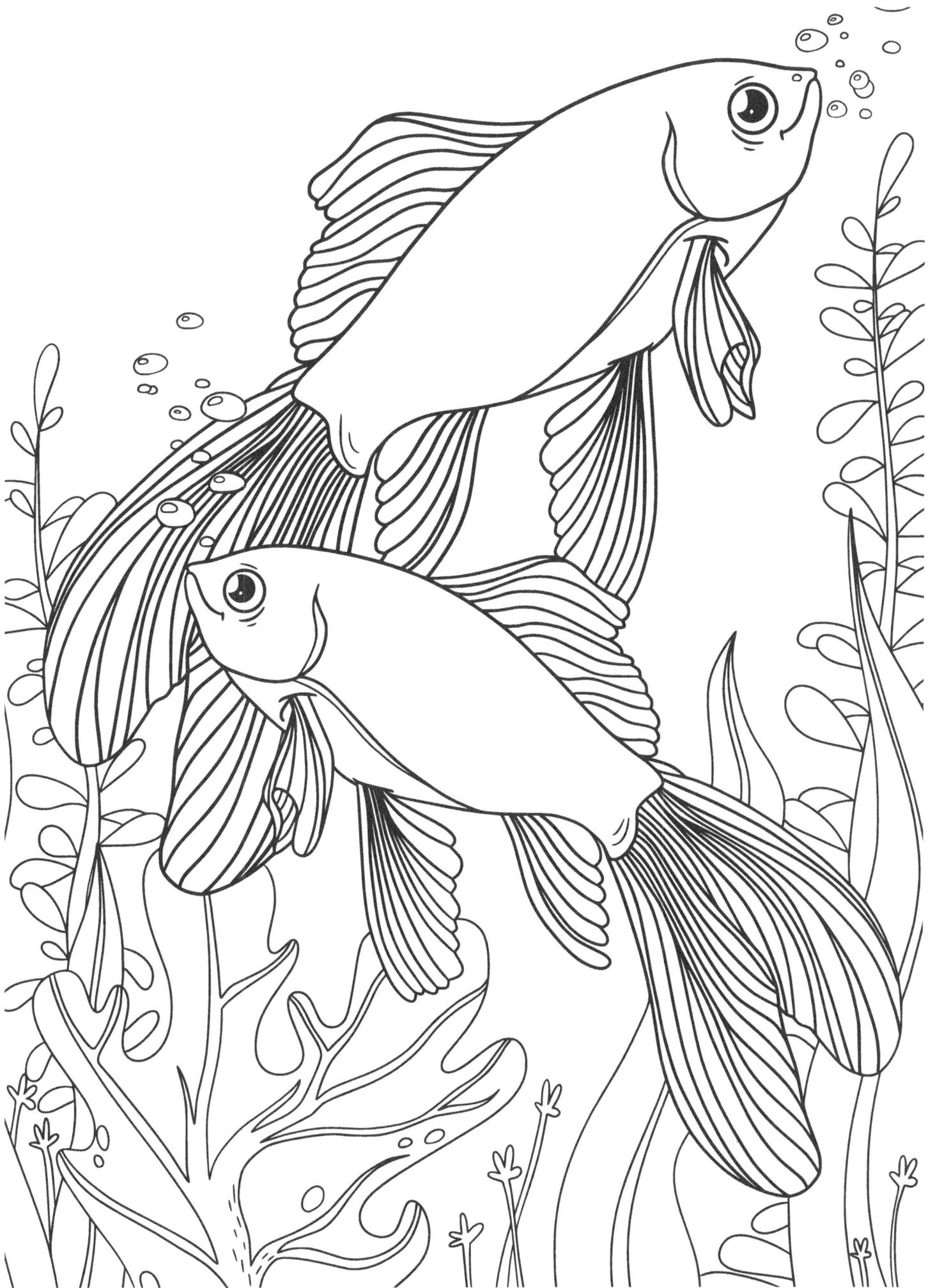

# Do You Know Who I Am ?

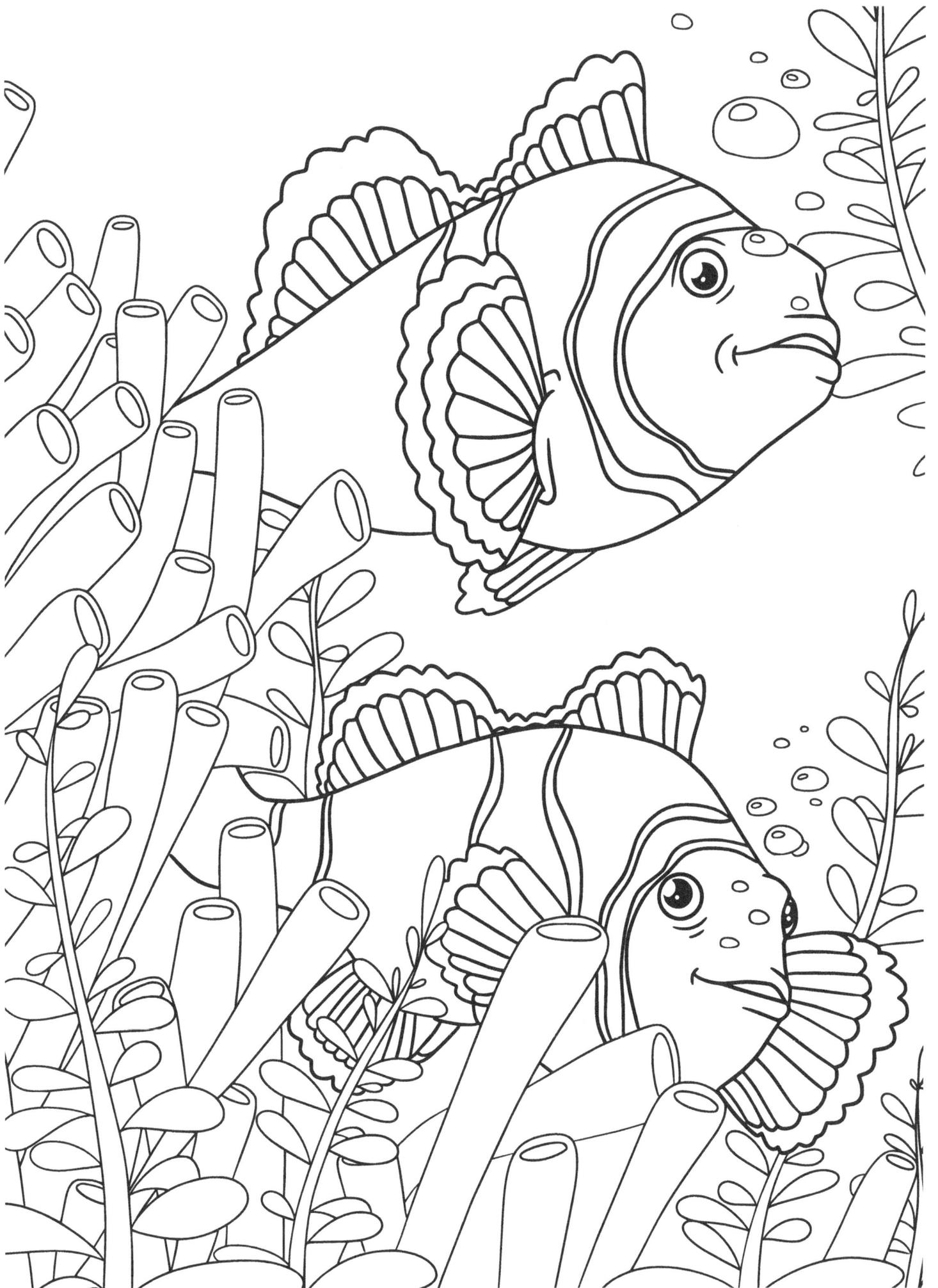

# Do You Know Who I Am ?

We are very grateful for your purchase of this coloring book. Please provide suggestions and give us a 5-star rating on Amazon so that we can improve to make our next book even better, thank you so much!

*Colograce*

Made in the USA
Las Vegas, NV
30 May 2022